THE ART OF JAPANESE JOINERY

THE ART OF
JAPANESE
JOINERY

KIYOSI SEIKE

TRANSLATED AND ADAPTED WITH AN INTRODUCTION
BY YURIKO YOBUKO AND REBECCA M. DAVIS

WEATHERHILL
Boulder

This book was originally published in Japanese by Tankosha under the title *Kigumi*.

WEATHERHILL
An imprint of Shambhala Publications, Inc.
2129 13th Street
Boulder, Colorado 80302
www.shambhala.com

© 1970, 1977 by Tankosha

First edition, 1977
Twenty-ninth printing, 2024

Printed in China
Shambhala Publications makes every effort to print on acid-free, recycled paper.
Weatherhill is distributed worldwide by Penguin Random House, Inc., and its subsidiaries.

Library of Congress Cataloging-in-Publication Data: Seike, Kiyosi, 1918– / The art of Japanese joinery. / Translation of Kigumi. / 1. Joinery. 2. Woodwork—Japan. / I. Title. / TH5662.S3813 / 1977 / 694'.6 / 77-9070 / ISBN 978-0-8348-1516-2

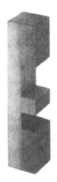

Contents

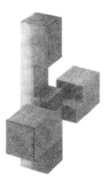

Translators' Introduction

Historically, the traditional Japanese carpenter has been architect and engineer as much as carpenter or joiner. Because his role has been so momentous, it is impossible to divorce discussion of Japanese joinery and carpentry from discussion of Japanese architecture itself. Carpentry in Japan developed within a family-guild system that appears to have been at times unrivaled anywhere in its absolute authority and absolute protection of secret guild techniques. Not only were there specialized guilds, such as those for shrine, temple, and domestic construction, but there were rival groups of specialized guilds in different areas of the country. The Osaka-Kyoto–based guild groups, which rose to a powerful position after the imperial capital was moved to Kyoto in 794, were long the arbiters of design, and the Kyoto standard (or *kyōma*) they established is still recognized as a desirable module for construction.

With the transfer of the government seat to the marshy village of Edo (present-day Tokyo) at the beginning of the Edo period (1603–1868), the upstart backwoods carpenters of Edo, or so they must have seemed in the eyes of established Kyoto carpenters, began competing fiercely for supremacy. The Kyoto-Edo guild battle was never resolved decisively, each group eventually retaining ascendancy in its own area. The net result of this sometimes acrimonious rivalry was a partial melding of design standards, and incidentally a great deal of exciting material for architectural historians to work with. Many of the secrets of these family guilds are now known to us, some from documents prepared while the Kyoto-Edo battle was raging, and although many of the guilds have long since disappeared, the heritage of their traditions lingers.

The earliest evidence of primitive carpentry in Japan is the remains of scattered pit dwellings, in which a wooden framework was raised over a pit and then covered with some form of thatching. By about 3000 B.C. we find evidence of established pit-dwelling settlements scattered throughout central Honshu. While it may seem overly generous to dignify such structures with the term architecture, they were designed—in several distinct styles—engineered, and constructed by man; in following millennia they spread throughout Japan in one fairly consistent style, becoming the architectural standard; and they were tenacious, persisting as dwellings until the late sixteenth century. Even in this century, temporary structures thought to be descended from these

pit dwellings are to be found in the countryside as rest shelters for people working in rice fields.

The first great revolution in Japanese joinery and architecture occurred during the Yayoi period (200 B.C.–A.D. 250), with the introduction of iron tools. The carpenter now had the implements with which to fashion tenons and mortises. Post and lintel construction, which had previously been limited by what the carpenter could achieve through ingenious lashing with vines or rope, finally came into its own. Japanese architecture took a radical leap, from ground-level wood and thatch construction to elevated wood construction in two distinctive styles, one a log-cabin type made with whole logs, the other a log-cabin type made with dressed planks. Early products of the new technology appear to have been storehouses or granaries and may have included a few dwellings.

During this period Shinto shrine construction also began, and it is probable that before the end of the Yayoi period the first buildings at Izumo Taisha (Great Shrine), Japan's oldest shrine, were already well established. It is also possible that during this period, with the beginnings of specialized architecture, carpenters were forming the first rudimentary family guilds, which were to play such an important role in the history of Japan's carpentry and architecture. Around the end of this period, diplomatic contacts that were later to have far-reaching effects were established between the courts of China and Japan.

The next major period of Japan's history did not see any great technological revolutions in carpentry, but was one of consolidation, both politically and architecturally. The outstanding feature of the Tumulus period (250–552) is the great mounded tombs from which the period takes its name. Most of the tombs are the mausoleums of early leaders and, finally, emperors, who had at last managed to weld the numerous independent states of Japan into one unified country. This political consolidation was to have a lasting impact on carpentry and architecture in Japan. During the Tumulus period wooden dwellings became far more common, even including a palace of sorts for the emperor, and Shinto shrine construction burgeoned. The unified Japanese court, which now had more contact with the continent, extended its loose influence to the southern part of Korea for about one hundred years, from the late fourth century to the late fifth century. During that time groups of carpenters emigrated from Korea to Japan, there to join a hereditary corporation, or family guild, of naturalized immigrant carpenters who were already firmly ensconced in the field of official construction for the state.

While these immigrant carpenters may have brought new techniques with them, they seem to have had little direct influence on what had become an established indigenous architectural style. Ise Jingū, or Ise Grand Shrine, is believed to have been first built in the late fourth century; but because of the system of regular, periodic rebuilding of major Shinto shrines, duplicating the previous construction, the original structures of Ise Jingū have long since disappeared. The twenty-year rebuilding cycles at Ise Jingū were interrupted several times by lengthy periods of civil war, and this resulted in an inevitable corruption of its architectural style. Comparison with Yayoi-period artifacts, however, shows that the majority of Ise Jingū construction is faithful to the architecture of the Yayoi period, when shrine architecture was born. There is no doubt that the actual techniques used at Ise Jingū are of great antiquity, for not

only are the joints simpler than those we find in later architecture, but a large number of the joints were never intended to be reinforced with nails, which were not generally available at the time that the first shrine was built.

During the Asuka period (552–646) the importance of Japan's contacts with the continent increased, culminating in the introduction of Buddhism to Japan, and with it the second great revolution in Japanese joinery and architecture. Along with the foreign religion came a group of immigrant Buddhist carpenters in the mid-sixth century who brought with them not only a whole new technology but also an architectural style radically different from any previously seen in Japan. Japanese carpenters quickly assimilated the new technology and by 607 they had built the great Buddhist temple Hōryū-ji, near Nara. That complex was razed by a still-mysterious fire not long after completion but was immediately rebuilt. The oldest extant wooden structures in the world, the Golden Hall (679) and the Pagoda (693), date from this rebuilding. By the end of the seventh century, Buddhist temple architecture was firmly established in Japan.

Although Japanese carpenters quickly assimilated the new technology and mastered the engineering of the complex bracketing that characterized Chinese Buddhist architecture, they were at the same time subtly changing the imported architectural styles and adapting the technology to the indigenous Japanese styles. It is at this point, following the second great revolution in Japanese joinery and architecture, that Dr. Seike takes up his study of the art of Japanese joinery.

In Japan today, carpenters still specialize in construction of Shinto shrines, Buddhist temples, or residences; but we have yet to hear of a carpenter qualified in all three fields, and for good reason. The vastly different histories and design and engineering requirements of these varied structures resulted in, among other things, a seemingly endless proliferation of joints, with a combined total of several hundred distinctly different joints (one practicing carpenter of our acquaintance has put the number at somewhere around 400 joints still in common use today). Surprisingly few of these joints are used in all three types of construction, and some are reserved for only one type of construction. The 48 joints that Dr. Seike has selected for this book are, for the most part, common to all types of Japanese architecture.

Even though some joints in this book are familiar in the West, they appear somehow different when seen through the eyes of a Japanese carpenter. Small differences between Western and Japanese carpentry begin, in some cases, from the moment a tree is marked to be felled. If the tree is going to be used in the construction of a Shinto shrine, for example, it and the area around it are purified before the woodcutter, who has also been purified, begins to cut it down. In the small lumberyards to be found in every neighborhood, lumber is stored vertically instead of horizontally. The various knife-handled traditional saws cut on the pull or backstroke, affording greater accuracy in cutting, which compensates for the loss in cutting power. The traditional plane must be drawn toward the carpenter and cannot be made to work properly any other way.

Although these differences are superficial, to be sure, they do reflect the deeper underlying differences between Western and Japanese carpentry that are, as Dr. Seike reveals, so intimately bound up with the entire history of architecture and carpentry in Japan. The differences are to be found both in work methods and in attitudes. During

the 1973 rebuilding of Ise Jingū, the shrine carpenters, who had been recruited from all over Japan, did their work with the same specialized tools that have been used by shrine carpenters for centuries. And like their predecessors, each carpenter had made his own tools, for they are not only a part of his craft but a part of him. Electric tools were in evidence in some of the workshops, but they were used only for roughing out, not for the "real" work that the traditional carpenters were there to do in the traditional manner.

To those readers interested in digging further into the fascinating history of Japanese architecture itself, we would recommend Yasutada Watanabe's *Shinto Art: Ise and Izumo Shrines*, Kiyoshi Hirai's *Feudal Architecture of Japan*, Naomi Okawa's *Edo Architecture: Katsura and Nikko*, and Teiji Itoh's *Traditional Domestic Architecture of Japan*, all published by John Weatherhill, Inc., New York and Tokyo. Together these books form an excellent survey of the indigenous architecture of Japan.

A word should be said about the method of translation. While we have adapted and restructured large parts of Dr. Seike's text, we have tried to retain the flavor and style of the original. Because carpentry is a highly technical art it is, in any language, full of highly technical terms. Unfortunately, because Japanese carpentry and architecture are so different from anything in the West, there are no direct translations for the majority of the traditional technical terms. Only three of the joints in this book (the cross lap, common dovetail, and beveled shoulder mortise and tenon) have legitimate equivalents in English; hence, we have resorted to descriptive translations for all others. Although some of the joints in this book may be familiar in the West under a particular name, because the Japanese carpenter's perception of the joint differs from his Western counterpart's perception, in all such cases we give precedence to the Japanese carpenter's view.

One final word about translation. *Daiku*, the Japanese word always translated as carpenter, is composed of the characters 大 (*dai*, chief) and 工 (*ku*, artisan), and its closest English equivalent is "architect," whose Greek roots are *archos* (chief) and *tektōn* (carpenter). Not only etymologically but also in terms of responsibility and function, the Japanese carpenter's true Western counterpart is the architect. Although we have long felt that "carpenter" is an inadequate translation of *daiku*, it is so well established that we use it here, though with reservations. As Dr. Seike is quick to point out, Japan's *funa-daiku*, which can be translated as ship's carpenter or shipwright, is known in English as a naval architect, and it does seem that Japan's *daiku* is being unjustly denied his due.

We would like to thank Miriam F. Yamaguchi, of John Weatherhill, for her invaluable assistance during the preparation of this translation. We are also grateful to Y. S. and, most especially, to C.O.

<div align="right">

Yuriko Yobuko
Rebecca M. Davis

</div>

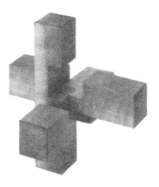

1. The Genesis of Japanese Joinery

Where Wood Has a Soul Because Japan was heavily forested, the architecture she developed contrasts sharply with that favored in many other areas of the world. In Europe and China, for example, where both stone and good clay for brickmaking were abundant, the mason's art developed and flourished. But the volcanic soil of Japan and other Pacific islands, which offered few materials to tempt a mason, yielded a seemingly endless variety of trees and other plants suited to a different type of construction. Thus, as European and Chinese masons were developing techniques for stacking stones and bricks atop one another, Japanese carpenters were experimenting with the post and lintel construction basic to wooden architecture.

While the most highly developed mason's art is to be found in Europe, Japan undoubtedly enjoys the most advanced techniques of wood construction. The seventh- and eighth-century structures at the Nara temples Hōryū-ji, Tōshōdai-ji, and Shin Yakushi-ji, for example, show the Japanese adaptation of mainland architectural forms introduced into Japan by that time. Even in these early structures we can see evidence of the advanced wood-construction techniques already used by the ancient Japanese.

It may seem paradoxical to state that Japan's highly developed joinery techniques resulted from her abundant timber; however, that abundance encouraged an almost exclusive concentration on wood construction. In order to continue that tradition once all the good timber had been felled, it was necessary to use the inferior timber that had been passed over earlier. The challenge presented in constructing a plumb and true building from the gnarled and knotted timber that remained undoubtedly led to the creation and development of both new techniques for joining wood and the tools with which to work the joints.

For a modern example of the problems of working with poor timber, we need look no farther than the wooden bathtub traditionally favored in Japan. Until twenty or thirty years ago, the bathtub maker split his boards out of a section of a tree because that yields more boards. But this method works well only with good, straight-grained timber. Since today's bathtub maker can usually get only timber of lesser quality, he has had to stop splitting off his boards and begin sawing to get usable boards from the knotty timber left to him.

Although the abundance of timber definitely contributed to the concentration on wood construction in Japan, other factors affected this choice of materials. One of these is the sheer destructive force of nature as seen in the numerous typhoons and earthquakes Japan experiences. Wood construction, because of its smaller mass, is better able to withstand earthquakes than is stone or brick construction. During an earthquake, the joints so necessary to wood construction function somewhat like shock absorbers, affording wooden buildings a certain amount of give, which is not possible with rigid stone or brick construction. Other factors favoring the choice of wood in Japan include the native timber's natural resistance to attack by bacteria, fungi, and insects, and the native termite's lack of vigor. Although termites have destroyed virtually all the older wooden buildings throughout the South Pacific, in Japan they have done very little damage.

Most native timber, such as pine, cedar, and Japanese cypress, is coniferous and grows well in temperate Japan. From earliest times, however, imported timber, variously called *karaki* (literally, "precious foreign wood") or *tōhemboku* (once meaning "precious unusual foreign wood"), was mostly of the broad-leaved variety, such as teak, red sandalwood, ebony, Indian ironwood, and lauan. In the Pacific, coniferous timber was peculiar to Japan, where the abundant rainfall and very warm growing season contributed to rapid summer growth and strong, beautifully grained timber. The Japanese climate was as admirably suited to the conifers as those tall, strong, easily worked straight-grained trees were to Japanese architecture.

Numerous Japanese leaders of the past have promoted and supported reforestation projects. The level of their activity and their success is demonstrated by the fact that much of the building timber used today, for example, the prized cedar from Akita Prefecture in northern Japan, was planted during the Edo period (1603–1868) by these far-sighted leaders. Although these reforestation projects may have been politically or economically inspired, I believe they were largely a result of the deep, almost religious reverence the Japanese have for trees. While most mountain residents know the names of only a few kinds of seaweed and most seaside residents know the names of only a few mountain wildflowers, everyone in Japan knows the word *kodama*, literally, "the spirit of a tree." I think it must have been an early faith in this *kodama*, this spirit of a tree, that caused the Japanese people to revere their trees, to care for them, and to actively promote reforestation. This same reverence no doubt accounts in part for the innumerable trees throughout Japan that are considered sacred.

Lebanon was once famous for its cedars. Phoenician fleets were built of the cedars of Lebanon, as was at least part of Solomon's Temple, and a 140-foot ship, excavated in superb condition from a pyramid and reassembled, was built of Lebanon cedar some 4,500 years ago. Yet today the famed forest lands of Lebanon are barren; only a few trees, protected as national monuments, remain as testimony to the ancient riches. Perhaps reforestation was not practiced in Lebanon or perhaps effective forest management was not possible because of climatic conditions. Whatever the cause, the result is a great loss to Lebanon and to the world: the once rich Lebanese forests are now a sere wilderness. The Japanese, in particular, should be grateful for their still-green mountains and for the fact that their ancestors fostered one of the earliest successful reforestation programs in the world. Perhaps, then, the Japanese, as developers of highly advanced carpentry techniques and as pioneers of reforestation,

have a special obligation not only to their own children, carpenters, and ecologists, but to future generations outside their archipelago.

In contrast with inorganic building materials and more recently developed high-molecular building materials, timber requires an almost animistic faith of the people who work it. I suspect that even noncarpenters cannot escape the inclination to ascribe divinity to the mystery of nature that creates beautifully grained wood. In Japan, various myths and legends immortalizing the divine nature of particular trees survive even today in stories recorded and handed down to us in literature and in picture scrolls. It is not because my understanding of theology is wanting that I cannot help believing in the divine nature of a tree when I see that through some mysterious inspiration it has been enhanced and transformed into artistic expression. When I look at a beautiful example of wood construction, I cannot help thinking that the beauty of the architecture derives not only from its design and construction techniques but also from the very soul of the wood itself. At the same time, fine wooden structures seem to speak with the hearts of the master carpenters who constructed them with obvious respect for the soul of their timber.

Wooden Structures It is often pointed out that wooden buildings are highly vulnerable to fire. Certainly this is true in large, congested cities; but in the days when Japan's cities were not so crowded that houses had to be built literally eaves-to-eaves, wooden structures were rarely destroyed by fire. In Japan today, a great many old wooden buildings survive in out-of-the-way places that were not plagued with the fires that commonly attended civil strife. Actually, the majority of fire damage suffered in Japan in the past resulted from the battle tactic of deliberately firing buildings; and it was not until quite recently, with the advent of arsonists and the increase of fires caused by gas and kerosene stoves and heaters, that our wooden structures began succumbing to fire in greater numbers.

But a comparison of fatality statistics is much more revealing: the number of deaths recorded for fires in buildings constructed of such noncombustible materials as concrete far exceeds the number recorded for fires in wooden buildings. Equally interesting is the fact that wooden buildings often survive a fire largely intact. For example, the oldest wooden structure in the world, the Golden Hall, built in 679 at the temple Hōryū-ji, near Nara, suffered a fire in 1949. Of the priceless murals on its walls, many were destroyed and others were badly damaged, but almost all its structural members survived undamaged. Today, after surprisingly small-scale repairs, this ancient wooden building is still in use and still open to the public.

In Japan, countless people have witnessed fires in ordinary wooden dwellings and noticed that the commonly used 10 cm. square posts (roughly 4″ × 4″) and 30 cm. square beams (about 12″ × 12″) generally remain in place, even if badly charred. Wood does not begin to burn until it reaches a temperature of about 300°C (575°F); but since wood is such a poor conductor of heat, even when the surface temperature reaches 300°C the heart of a substantial building member is little affected and will continue to support the load it was intended to support. Hence, we can say that in a fire, wood construction is actually safer than steel-frame construction, since steel is a very good conductor of heat, bending like soft taffy at 800°C (1472°F) and warping badly at lower temperatures. Steel stairways are hazardous during a fire, since at rel-

atively low temperatures they quickly become too hot to step on and at higher temperatures they warp, losing their shape entirely at very high temperatures.

Although steel-frame construction appears safer at first because it is itself non-flammable, during a fire it is actually less trustworthy than wood-frame construction. For example, because steel is an efficient heat conductor, very hot steel stairs cannot easily be cooled enough with water to be usable in a fire; yet because wood is an inefficient heat conductor, wooden stairs can so easily be cooled that they can be used even with flames licking at them. Sturdy wooden stairs are fairly safe in the early stages of a fire, since the heart of the timbers is unaffected and it is necessary to cool only the burning surface, which does not retain heat as well as steel does. Hence, we should not cavalierly dismiss wood construction because the basic material is flammable.

Because wood is such a poor conductor of heat, it generally maintains an even temperature relative to the season and is warm to the touch even in midwinter. In very humid countries like Japan, stone buildings will sweat greatly on a muggy day; and marble-faced buildings sweat so much that they become very uncomfortable in moderate weather and almost unbearable in humid weather; but wood construction rarely sweats, since it can absorb the normal levels of surrounding humidity. This alone would persuade me that wood construction is most suitable in a humid country like Japan, even if I did not take traditional Japanese aesthetics into consideration. This is not to say that the ancestors of the present-day Japanese eschewed or had no skill at stone construction; on the contrary, at archaeological sites dating from about 3000 B.C. to the seventh century A.D. we find an abundance of stone construction, interspersed with pit dwellings and stone burial mounds, to remind us that wooden architecture is, in Japan, a relatively recent innovation. But we must keep in mind that once in use it quickly became the primary architectural medium.

Kiwari: **Construction Proportions** It is generally held that the beauty not only of architecture but of all things, both man-made and natural, derives from their proportions. In architecture the ancient Greeks, in particular, experimented with proportions, eventually establishing the Doric, Ionic, and Corinthian orders, based on highly developed ideal standards of proportion. In Japan, too, people experimented with architectural proportions and developed a kind of order, an ideal standard of proportion. This order is known as *kiwari,* literally, "dividing wood," but meaning "determined construction proportions." *Kiwari* eventually gave rise to a formalized system of prescribed design techniques known as *kiwari jutsu,* or the art of determining construction proportions.

Although the word *kiwari* did not come into use until the early seventeenth century, near the beginning of the Edo period, at different times before the Edo period two separate words had been used to identify the concept of determined construction proportions. Thus, it would be proper for us to consider *kiwari* a very general term, not referring to a specific order or set of ideal proportions but encompassing the larger concept of proportional relations among the individual structural members of a building.

If we accept *kiwari jutsu* as a recognized discipline governing construction, we can discern clearly established relations among the proportions of structural members of buildings erected as early as the Nara period (646–794) and during Japan's middle

ages, the late twelfth to late sixteenth century. In particular, we notice well-defined standards for posts, based on the thickness of structural posts and on interpost spans, and for roofs, with heavier roofs requiring thicker, more closely spaced posts.

If we consider the relation of interpost span and post size, in ancient architecture the uniform distance between posts appears rather narrow in relation to the massive size of the posts or pillars. But in time, technical advances, no doubt stimulated by the rising costs of materials, resulted in progressively less massive posts spaced farther apart. If we compare one of Nara's older temples, the Tōdai-ji, built in the first half of the eighth century, with one of Kyoto's more recent temples, the Chion-in, rebuilt in the 1630s, the earlier temple appears very massive and imposing, while the later temple leaves a lighter, more delicate impression.

Until almost the beginning of the Muromachi period (1336–1568) architectural proportions gave an impression of great strength and beauty. But the increasingly far-reaching effects of the incessant civil war of that period included both the destruction of a great many imposing older buildings and a shift from the earlier massive structures to equally pleasing styles that were easier and less expensive to construct, or reconstruct, as occasion demanded. Although the use of decorative sculpture, carving, coloring, lacquer, and metal fittings to ornament buildings was developed to a sumptuous degree during the Momoyama period (1568–1603) and the Edo period (1603–1868), at the same time, in the actual framework of buildings the proportions, or *kiwari*, of the various structural members are greatly reduced when compared with earlier buildings. Among various buildings intended for the tea ceremony and among buildings in the *shoin* style of architecture adopted by aristocrats, warriors, and priests toward the end of the Muromachi period, we do find many very beautiful structures; but theirs is indeed a rather delicate beauty when compared with buildings of earlier periods.

Many different *kiwari* systems, each with slightly varying standards of ideal proportions, were developed and handed down from generation to generation. The oldest extant system was developed before the Kamakura period (1185–1336) by the Abè family, traditional master shrine carpenters from Shiga Prefecture. Among the several extant *kiwari* manuals that were eventually compiled, perhaps the most famous is the five-volume *Shōmei*, prepared in 1608 by the Heinouchi family, who served the government as master builders and chief carpentry supervisors. It might at first appear that the various manuals were intended to preserve rigidly exacting standards of design, but in all honesty, we cannot be certain that any structure was ever built in strict accordance with the rules set forth in these manuals. Perhaps we should consider the surviving manuals as general reference works, architectural encyclopedias in which all the existing technology of Japanese architecture was assembled and presented in a systematic form, setting patterns for modern Japanese architecture.

The *kiwari* manuals anticipated such questions as what is a good height for a ceiling. When a ceiling is too low, it leaves us with a cramped, gloomy feeling; when it is too high, it seems loose, disconnected from the room. And will one ceiling height work for all rooms? To answer such questions, some kind of standard is needed. According to the established patterns, in a six-tatami-mat room (roughly 9.7 sq. m., or about 104.6 sq. ft.) the ideal ceiling height is 60 cm. (about 23 7/8") from the bottom edge of the lintel, and in an eight-tatami-mat room the ideal ceiling height is 80 cm.

(about 31 1/2") from the bottom edge of the lintel. Since the standard distance from the sill to the bottom edge of the lintel is 180 cm., we know that according to *kiwari* systems the ideal height for the ceiling of a six-mat room is 240 cm. above the sill, and for an eight-mat room 260 cm. above the sill.

Besides setting forth such standards for the modular composition of space, the *kiwari* manuals also gave detailed consideration to many structural elements, including the relationships among the size of the structural posts, the spacing of rafters, and even the proper dimensions of *shōji* (sliding panels made of translucent paper mounted on one side of a latticed wooden frame and used as either windows or doors). For example, if the structural posts of a building are 12 cm. square, then exposed beams should be 9.5 cm. square, and the frame members of *shōji* should be 3.4 cm. square.

Space I believe that one salient characteristic of Japanese art and culture is the emphasis on *ma*, a space or interval. In Nō plays, for example, a small hand drum is struck; the beat is followed by silence; then the drum is struck again; that beat is followed again by silence; and so on. This *ma*, the interval between the soundings of the drum, which is characteristic of Japanese music, is not related to the pause or rest found in Western music. In Japanese music, even when there is no sound, something vital remains.

To the Japanese, *ma* is not just an empty space, where nothing exists: it is the space or interval necessary to give shape to the whole. One of the more vulgar derogatory terms in Japanese is *manuke*. In use, its meaning is something on the order of "grossly stupid," but its literal meaning is simply space (*ma*) that is missing (*nuke*). That *manuke* is considered such a strong insult that it can lead to blows is, I think, a good indication of just how important the presence of space, or *ma*, is in Japan.

In construction, *ma* referred simply to the space between structural posts. Among the many architectural terms derived from this word are *magusa*, or lintel, which in-itially meant the material (*kusa* or *gusa*) that was put into a *ma; and mado*, or window, which was basically a door (*to* or *do*) that was put into a *ma*. Originally the *ma* was not a unit of measurement; but the Sino-Japanese ideogram that can be pronounced *ma* was also used to indicate the actual measured distance between posts, and in that usage it is pronounced *ken*.

The *ken* is the fundamental measurement of modular construction in Japan, but this basic unit has been a variable one. At first one *ken* was equal to one *jō*, or three meters. Then the *ken* came to be measured in terms of the *shaku*, about thirty centi-meters, roughly equivalent to the English foot. At that time, in the mid-sixteenth century, one *ken* equaled seven *shaku*, or about 2.12 meters. Later the *ken* equaled 6.6 *shaku*, or about 1.99 meters. The *ken* shrank further to 6.3 *shaku*, about 1.9 meters; then to 6 *shaku*, or about 1.82 meters. Quite recently, however, the *ken* has shrunk to exactly 1.8 meters. It seems distinctly odd that while the height of the average Japanese has been increasing steadily over the centuries, the measured length of the *ma* has been decreasing just as steadily, reducing the overall size of buildings. But I suppose that the *ma* became the established standard module for structures without regard for what the actual measured length of a *ma* was at any given time.

Although the *ken* has been a changing measurement, its relation to the *ma* has remained constant. In modular construction a *ma* is invariably one *ken* long, while a

supplemental measurement of half a *ken* is used to permit flexibility in construction. Since the *ma* refers not only to width but to height, it is actually a square space, one *ken* by one *ken*, measured from centerline to centerline. A square *ma* of floor space, called a *tsubo*, is equal to two tatami mats.

Determined construction proportions, *kiwari*, were based on a modular coordination that was intimately related to everyday life. This relationship is seen not only in the sizes of tatami mats, but even in furniture. For example, in the old days the standard dresser was 3.1 *shaku* wide (about 93.94 cm.), 1.4 *shaku* deep (about 42.42 cm.), and 1.7 *shaku* high (about 51.5 cm.). It occupied about 1/4 tatami of floor space, and though quite heavy when full, was still small enough that it could be quickly removed from a building, in the event of a fire, for example. When the *ken* equaled 6.3 *shaku*, about 1.9 meters, two of these dressers easily fitted side by side into a one-*ken ma*, or one fitted comfortably in a half-*ken ma*.

In recent years, wood construction has been displaced more and more by ferroconcrete construction; yet since the measured length of the *ma* has not changed, new problems arise. Because of the materials used, the walls of a ferroconcrete building must be at least 20 cm. thick; hence its *ma* measured from centerline to centerline results in a room very much smaller than a comparable room in a wooden building with 12 cm. square posts. In Japan this further reduced ferroconcrete *ma* is called "danchi-size," *danchi* being a nickname for the public housing complexes that marked the beginning of concentrated efforts in ferroconcrete construction. But the term "danchi-size" is only a deceit, an attempt to give this reduced *ma* an air of legitimacy by giving it a name. For example, in a house using Kyoto-size tatami (6.3 *shaku* by 3.15 *shaku*), a room of four and a half tatami mats has a floor area of 9.6 square meters, while a *danchi*-size four-and-a-half-mat room has an area of only 6.2 square meters. In fact the Kyoto-size four-and-a-half-mat room is actually larger than a *danchi*-size six-mat room, which has an area of about 8.2 square meters.

Carpenter's *Dōgu*, or Instruments When we think of wooden architecture, we usually think of post and lintel construction, with all the members meeting at right angles. But there are many buildings in which the emphasis is on a diagonal element, or curved surfaces, or a parabolic roof. There is a growing interest in seeking solutions to the problems of constructing such buildings, and we saw many unusual buildings constructed in Osaka on the site of EXPO '70.

In wooden architecture, however, the majority of construction employs straight lines, primarily because of the characteristics of wood and the nature of its growth. There are obvious exceptions, such as wooden ships with their curved, sloping hulls, gracefully curved furniture formed from a single piece of wood, and unusually shaped kitchen utensils. But in such cases, the shipwrights, furniture makers, and other craftsmen have had to develop techniques for forcing wood to assume and retain an unnatural shape.

In addition to the wide variety of timber available, which makes it possible to select wood with the properties best suited to the intended use, technical advances in processing timber have resulted in a new variety of building materials. Strong, relatively lightweight plywood can be molded in a variety of shapes while retaining its strength; and particle boards, made of wood flakes bound together with synthetic

resins, also lend themselves to new shapes. Because of such new materials and the tools with which to mold them, it has become possible to move away from the traditional straight-line construction in wood and experiment with many new forms and shapes. While the use of large sheets of plywood has resulted in an enormous saving of time and energy in putting down subflooring, for example, the wide range of electric woodworking tools now available has not only saved time and energy for carpenters but also altered woodworking techniques.

Although modern technology has given us new materials and new tools, Japanese carpenters still use a very special, respectful term for their instruments, even their electric tools. No Japanese carpenter refers to his instruments as mere "tools," but instead calls them *dōgu*, which really has no equivalent in another language but means roughly the "instruments of the Way [of Carpentry]." *Dōgu* is a very old word and perhaps it has not disappeared because even though materials and tools have changed and improved, carpentry methods and the "Way of Carpentry" have remained basically unchanged for hundreds of years. A certain pride in being an accomplished professional carpenter may also contribute to the reluctance to demote those instruments to tools.

Originally, a *dōgu* shop was one dealing in implements and equipment for the tea ceremony. The various implements used in the tea ceremony—*sadō*, or the Way of Tea—were called *dōgu*, or "instruments of the Way [of Tea]." Carpenter's tools also came to be called *dōgu* because for carpenters there is a Carpentry *Dō*, or Way of Carpentry; and carpenters, too, considered their implements *dōgu*, or instruments of their Way. Although many artisans use implements unique to their crafts, these implements are always called tools, never *dōgu*. To a Japanese carpenter, his *dōgu* have a significance far removed from that of the mere tools that other craftsmen might use. Nowadays, however, the carpenter's *dōgu* are not so highly respected and valued as they once were, perhaps because the most highly skilled traditional carpenters are now quite aged and so many younger carpenters lack the spirit and devotion that are the bedrock of fine workmanship. In the old days, for example, if an apprentice stepped over a saw, it was only natural for his master to strike him soundly for showing such disrespect for his *dōgu*. The apprentice would accept his punishment without complaint, knowing how gravely he had erred. Perhaps we could even say that formerly the carpenter's *dōgu* were invested with a degree of divinity.

According to a Chinese myth, a family named Fūshī devised the compass, square, level, and plumb line, collectively known as *kinorijunjō* in Japanese. Many consider this to mark the origin of true carpentry instruments, or *dōgu*. It is easy to imagine that the first *dōgu* employed to work wood were axes of various sizes, since the first step in working wood must be the woodcutter's. It is clear that the ax is among the oldest of man's tools, since it is found throughout the world in the oldest strata of man's debris. Because ancient Japanese axes are almost identical to contemporaneous axes found in China and Korea, it is surmised that the early ax came to Japan via the continent. And today's skilled carpenters can still do the most exacting work with only an ax.

We believe that the chisel and hammer or mallet were the first tools to follow the ax. It was not until the iron age that these stone implements were joined by the saw. In collections at the Hōryū-ji and in the Shōsō-in, the eighth-century repository of the Tōdai-ji, a few ancient saws are preserved, all with blades much thicker than those of modern saws. By measuring the width of kerfs, or saw cuts, found on ancient timbers

during one rebuilding of seventh-century Hōryū-ji structures we have been able to determine that the saws used in the original construction had blades about 5 mm. thick (about 3/16''). The blades of saws found in third- to seventh-century mounds are quite thick, although most of the saws are so badly corroded that we cannot determine either their original size or their original thickness.

One board commonly used in Japan was known as a four-*bu* board, since it was supposed to be four *bu* thick (about 12.12 mm., roughly 1/2''); however, measurement was considered accurate if the board was 2.3 *bu* thick (about 6.97 mm.). This acceptable difference of about 5 mm. is the result of subtracting the allowance for the kerf when cutting the board; but even today, with improved sawyer techniques that make it possible to produce boards of absolutely true measure, this 5 mm. allowance for the kerf is still accepted. In America, too, we see a similar allowance for the kerf: a 2 × 4, for example, should be 2 inches by 4 inches, but in fact the generally accepted measurements are short about 3/16'', the thickness of the kerf. We can therefore assume that for quite a long time about 5 mm. has been accepted as the standard thickness of a saw blade in both the Orient and the West. It is possible that the properties of ancient iron required thick saw blades. We cannot, of course, know the thinking of the creator of an early saw; but if we suppose that he considered each tooth of a saw as a separate cutting edge, like a minute adze or chisel, then it is probable that a saw was regarded as a blade with a series of little chisels set in a row along one edge. Such a perception would undoubtedly affect manufacturing methods and could account for the great thickness of early saws.

When the Hōryū-ji and Tōdai-ji were built, in the seventh and eighth centuries, the main carpenter's *dōgu*, or instrument, was an iron adze. Carpenters in those days did all their work, from roughing out to planing, with only an adze; even mortises were made with just an adze and chisel. With such primitive tools, however, the amount of lumber actually usable for construction was only about one-tenth of the timber that had been felled in the forest: the remaining ninety percent simply disappeared in the dressing and finishing. Even temples built as late as the Kamakura period (1185–1336), with their fine, delicate elements, were constructed with only the adze, saw, and similar tools, since the plane had not yet been introduced. Planes did not appear in Japan until around the beginning of the Edo period (1603–1868), and it has been suggested that they were introduced from China.

We should also give some thought to the basic measurements used in construction. In some ancient Japanese structures we find evidence of the use of a measure known as the Koguryŏ *shaku*. Since it is believed that the Koguryŏ *shaku* was used as a measurement in constructing numerous massive burial mounds surviving from the third to seventh century, it seems likely that it came to Japan from the Korean kingdom of Koguryŏ, becoming established as a standard measure in very ancient times. Among extant ancient carpenter's rules, one in the Shōsō-in is considered a national treasure. A similar rule that may have once belonged to the Nachi Shrine in Kishū, south of Osaka, has disappeared. It is believed that in addition to these few carpenter's rules we now know, many other standard measures were in use. But when we compare the ancient *shaku* used in different areas or structures, there is remarkably little variation among them. For example, the *shaku* used in 1124 in constructing the Konjiki-dō, or Golden Hall, of Chūson-ji in Iwate Prefecture, in far northern Honshu, equals 1.065

shaku (about 32.27 cm.) in modern measurements. The difference of 1.97 cm. between this and the modern *shaku* is probably an error arising simply from the rather primitive techniques of those days. Since the *shaku* used in construction in the then-pioneer countryside of northern Honshu was this accurate, we can assume that even at that early time a fairly standard *shaku* was in use, differing very little from one part of Japan to another.

The Roof Truss The one element common to all structures we call buildings is the roof, and I believe it is the most important structural element. We often speak of the "shape of a house" and in Japan that shape always includes, in our mind's eye, a triangular gable. The "shape of a house" calls to mind the same image in the West: neither Japanese nor Westerners are likely to visualize the flat-topped, boxy structures we find more and more in modern construction. Even the doghouses we build have pitched roofs. Hence, the shape of a roof is obviously an important element in the basic designs that determine the shape of a house, and in Japan, where rainfall is abundant, roofs with a steep pitch are a necessity. It could be said that *kigumi*, or wood construction, is basically the construction of roofs and posts, encompassing the composition of the roof truss and framework.

As Japan's forests became exhausted, the increasing scarcity of good timber needed for truss construction undoubtedly had a direct bearing on the development of the numerous techniques not only for splicing short timbers but for connecting structural members. In the West, joints fall into one of two general classes: a joint is either a butt joint or a lap joint. In Japan, too, joints fall into one of two classes: a joint is either a *tsugite* (splicing joint) or a *shiguchi* (connecting joint). In the West joints are classified according to the manner in which the pieces of wood are joined, but in Japan joints are classified according to their function. Thus a half lap joint used to join two pieces of wood end to end (Fig. 11) is classified in Japan as a *tsugite*, or splicing joint, and a cross lap joint used to join two members at a right angle (Fig. 55) is classed as a *shiguchi*, or connecting joint, while in the West both are classed simply as lap joints. Apart from serving to splice or connect timbers, *tsugite* and *shiguchi* should contribute to both the strength and the beauty of a structure. And in truss construction in Japan both strength and beauty are major considerations.

The most important architectural element in Japan is the rafter, both from a structural viewpoint, since the rafters must support heavy tiled roofs, and from an aesthetic viewpoint, since exposed-rafter construction has long been favored. It is no wonder, then, that from very early times Japanese carpenters have been preoccupied with rafters. In ancient times, although rafter distribution and density were closely related to the placement of roof tiles on a building, they had no relation to other parts of the structure, such as interior walls. It seems, however, that rafter distribution and density gradually came to be more related to other parts of a building and eventually to have a definite bearing on construction plans.

During the Kamakura period (1185–1336), when carpenters built a house they took its rafters as their standard, basing all other plans on that standard. Carpenters first determined the distribution of rafters and the interrafter spacing and on the basis of these decisions worked out all other details, from the placement and dimensions of individual rooms to the length of the overhang of the eaves. Later, with the development

of fan-rib or radial raftering (Fig. 7), construction planning started to become more precise, probably because more complex and exacting techniques are required in constructing fan-rib raftering. In time, fan-rib raftering became the basis of structural planning: carpenters first decided where to place the hip rafters, then determined the placement and density of the radiating common and jack rafters, and on the basis of this work completed the plans for a building. During this period, the rules of *kiwari*—or determined construction proportions—that applied to eaves construction advanced greatly, finally becoming codified.

Although *kiwari*, or *kiwari jutsu*, is basically the study of structural proportions, from the foundation of a building to its ridgepole, special emphasis is laid on the construction of the roof truss and rafters. Among the important structural proportions of a building, such as the roof, framework, and windows, the most important for traditional Japanese carpenters is the roof, because it not only determines the shape of a building but is also the distinctive feature that makes Japanese architecture look Japanese.

When Westerners draw pictures of Oriental architecture they usually draw buildings with sweeping roofs that resemble an inverted V that has been sat upon. It is quite true that a great number of Oriental buildings have such roofs, but in Japan the straight pitched roof predominates. Although one does find a number of sweeping roofs in Japan, one also finds a number of roofs with a pronounced camber. Both these roofs are difficult to construct. For example, to create the trailing curves of a sweeping roof we must rely on the plasticity of heartwood, but if we use only sound, straight timbers it is very difficult to create these shapes with wood alone. These sweeping roofs with their trailing curves, which were originally introduced from China and are still called "Chinese style" roofs, created many problems for Japanese carpenters, who tried to reduce the degree of warp in rafters, ridgepoles, and so on, while still fashioning an elegantly curved roof.

In order to construct a pitched roof one needs not only horizontal members, such as ridgepoles and tie beams, but also vertical members, such as king posts, and diagonal members, such as rafters and struts. Joining the various members of a complicated roof truss, which can be challenging to a carpenter, requires the use of some very complicated *tsugite* and *shiguchi*.

In constructing a roof truss, carpenters must take special care with joints where members come together from three directions, such as at the corners of the eaves of the Japanese-style hipped-and-gabled roof. Curved gable roofs were originally created by carrying a very long rafter down from the ridgepole over numerous purlins and the wall plates, ending in flaring eaves. But in hipped-and-gabled roofs, the hip rafter joins not the ridgepole but a secondary ridgepole that descends, just above the principal rafters, from the ridgepole. From this joint, the hip rafter sweeps out in a graceful curve. Although it should be impossible to build this kind of roof without welded joints at the connecting and supporting points, it was accomplished through the ingenious use of flying rafters to support the eaves, and it still seems almost magical. It should be pointed out, however, that these curving eaves were also used to disguise the natural deflection that normally occurred at the eaves.

In Japanese architecture there are numerous ways of constructing rafters to hold the sheathing and support the roof; and there are numerous ways of connecting the rafters to other parts of the roof truss, such as ridgepoles, purlins, wall plates, and col-

lar beams. A wide variety of splicing joints (*tsugite*) and connecting joints (*shiguchi*) was needed to create members of the necessary length, to join the various members of the truss, to achieve differing degrees of roof pitch, and to create curving eaves.

Some ancient buildings, for example, the eighth-century Main Hall of the temple Shin Yakushi-ji in Nara (Fig. 4), were built in a handsomely crafted bare-rafter style. Later treatment of gables and open attics included visible rafters, but the earlier bare-rafter style, which had displayed beautiful construction to great effect, had by then degenerated into a primarily decorative, formal exposed-rafter idiom of little distinction. Later, when closed ceilings were introduced, the defined space of the attic could no longer be seen. But these changes were accompanied by technical progress that made it possible, for example, to use various kinds of halved joints in attic construction to create deeper eaves.

The rafters visible in the formal exposed-rafter style were in fact a variety of flying rafter, as distinguished from the base rafters that actually support the sheathing and roof. Although it appeared that the true pitch of the roof could be seen from inside the attic, in reality the visible flying rafters used in the formal exposed-rafter style had a slightly smaller pitch than the base rafters. Because of an optical illusion, seen from outside, the roof appears to have a rather ordinary pitch, but seen from inside, the exposed rafters give the impression of a steep pitch. One type of gently arched exposed-rafter construction made with very little pitch was called the "boat bottom ceiling" because of its resemblance to the hull of a fishing boat. When carpenters had fully developed the formal exposed-rafter style, it was possible to employ a greater variety of splicing and connecting joints in the base rafters and truss, which were hidden behind the visible flying rafters. Here again technical advances were made in splicing and connecting joints.

Since the closed ceiling was unknown in the oldest architecture in Japan, the exposed interior of the open attic of a building was carefully and beautifully constructed. In recent times, far less care in construction has resulted in trusses that are both inaccurately made and vulnerable to damage, which may explain why so many modern buildings have leaky roofs.

In Japan, ceilings were originally called "dust catchers" and were intended simply to keep dust and debris from falling into a room from the exposed underside of the finished roof. In the beginning, *tengai*, loose, latticed canopies, were suspended from the truss to serve as "dust catchers." Eventually these evolved into more solid units attached to the framework of a room. Much later, such complex variations as coffered ceilings, coved ceilings, and coved-and-coffered ceilings were developed. With these ceiling variations also came advances in the splicing and connecting joints needed to construct them.

The so-called Japanese roof truss, or *kyōro-gumi*, shown on page 96, consists of a sometimes elaborate series of posts set on crossbeams, with the purlins, which support the rafters and roof, set on top of the posts. The Japanese roof truss may be unique in its use of whole, barked logs as tie beams, but they are preferred chiefly because that is the most economical way to obtain stout tie beams. During the Nara period (646–794), the *gasshō* truss style, shown in Figure 4, was quite commonly used. The *gasshō* style, however, is not considered a true Japanese truss and is almost identical to Western trusses.

Framework and Floor Framing Erecting a framework basically consists of putting sills on a foundation, standing posts on the sills, and laying beams on the posts. To this basic skeleton are added window frames, door frames, and so on. Then the framing for the fittings that will define the interior spaces is added. In Japan, the fittings that close off or divide space include not only solid walls but also *shōji* and *fusuma* (sliding partitions made of opaque paper mounted on both sides of a wooden frame and used primarily as room dividers). To strengthen the framing added to the basic skeleton, a variety of diagonal bracing, cross bracing, and so forth is added. Thus the framework includes not only the basic structural skeleton but all the members added to it either to define interior space or to strengthen the structure. And the most important points in the framework are the splicing and connecting joints used in the sills, posts, and beams.

Although a few horizontal structural members in Japanese architecture, such as exterior door lintels, are almost identical to their Western counterparts, there are a great many that are unique to Japan. There is, for example, a class of small beams called *nageshi* that are used at the top and bottom of the partial walls above *fusuma* or *shōji*. Originally, *nageshi* were functional structural members, but in modern times they have become almost purely ornamental. Now that *nageshi* have lost their true function, they are no longer dotted with the decorative nail covers devised to conceal the heads of the spikes that had been driven through the *nageshi* to reinforce joints. Also unique are the grooved lintels and sills that form the tracks that *fusuma* and *shōji* slide in. The grooves in the lintels, which are about six times as deep as the ones in the sills, were originally made by nailing strips of wood to the structural lintel; but now that routing tools are available these grooves are normally routed out of the lintel.

According to various myths and legends and the ancient historical chronicle *Kojiki* (Record of Ancient Matters; 712), in Japan, to "raise a post" means to begin the construction of a building. Perhaps the first posts were simply embedded in the ground. In prehistoric pit dwellings we do find post holes, often spaced fairly regularly, and it seems likely that the inhabitants of those dwellings added beams, braces, and rafters, lashing the members together with rope or vines. Dwellings of very similar construction are still to be found today on islands in the South Pacific.

Another way to build a house is by stacking up logs, which in a sense resembles building a house by stacking up bricks or stones. This is an ancient construction method in Japan, where it is called the *azekura* style (which is usually translated as the "log-cabin style") and has been used primarily in the construction of storehouses (Fig. 1). Because an *aze* is a ridge between rice fields and a *kura* is a storehouse, we presume that the *azekura* must be in some way related to a granary. Although we do not know when or whence the *azekura* style was introduced into Japan, where the primary construction technique was post and lintel, we should bear in mind that it, too, is included in what we call Japanese architecture.

The topmost part of the framework of a building is given a separate name: the roof truss. When the framing of the truss is finished, the framework of the house is considered completed; and in Japan, as in some Western countries, a celebration is observed at this stage of construction. The Japanese style of floor framing, similar to the construction shown in Figure 2, does not exist in China or in the West, where solid, closed foundations, joists, and subflooring are used. Altogether, Japanese *kiwari* consisted of floor framing, framework, and roof truss.

In ancient times commoners' houses in Japan generally had only hard-packed earthen floors, although they always had a wooden-floored sleeping area and often had a wooden floor in at least part of the main living area. The old Sino-Japanese ideogram now used in Japan to mean both "floor" and the Japanese-style "bed" originally meant only "bed." Because when this ideogram came to Japan from China a "bed" was simply a wooden-floored place to sleep, it is easy to understand how the meaning could have been broadened from just "bed" to include "floor," as well. There may also be an implication here that a wooden floor seemed artificial when compared with an earthen floor, much as a modern bed must seem artificial in comparison with a wooden floor.

Wood floors consist basically of sills, sleepers, joists, and floor boarding. In Japan, where humidity is high almost the entire year, good ventilation beneath the floor is essential to preserve the wood. Thus, it was very natural that a high, open foundation came to be preferred in Japanese construction.

Very often, the floors of Japanese-style houses are extended beyond the exterior walls as verandas. If we argue that the interior of a house has a floor and the exterior does not, then the veranda of a Japanese house must be considered as part of the interior. But if we argue that exterior doors or walls form a dividing line between the interior and the exterior, then the veranda must be considered as part of the exterior. In actual practice, however, the veranda is a sort of junction zone where the interior, or architectural, spaces and the exterior spaces of nature meet. Hence, the Japanese veranda is neither strictly interior nor strictly exterior, but is a bit of both.

Because the veranda is exposed to view, carpenters put a great deal of thought and care into the design and construction of its balusters and rails (Fig. 8). Their efforts did not end there, but extended to the design and construction of both the deep eaves that protect the veranda from the elements and the exposed rafters on the underside of the eaves (Fig. 5). Since veranda and eaves construction gave carpenters an opportunity to demonstrate their skills, the rules of *kiwari* that applied to the distribution of eaves rafters were among the most carefully guarded secrets handed down from one generation of carpenters to the next.

To be a slave to fashion is not in very good taste, but to be totally unfashionable is not in very good taste either. *Kiwari* has had its fashions, but as a criterion of beauty, it developed rather slowly. Throughout the long history of Japanese architecture, good ideas and poor ideas, ideas that worked and those that did not, were constantly reevaluated, contributing to the evolution and refinement of *kiwari*.

Determining the physical appearance of a house can be included among the *kiwari* techniques. If we think of design as a method of determining the most beautiful proportions, then in construction we could think of *kiwari* as a technique for building a module of beauty. In general, we cannot judge the truth, goodness, or beauty of a structure. But since it is possible to build a perfectly adequate or "correct" structure by adhering to the rules of *kiwari*, even though slavish imitation is not desirable, beauty can be created by following the rules of *kiwari*. Hence, just as laws are often revised to meet the needs of changing times, the rules of *kiwari*, as a fashion, may also change.

1. Sutra Repository, 8th century, Tōshōdai-ji, Nara

2. Honden, rebuilt 1744, Izumo Taisha, Shimane Prefecture

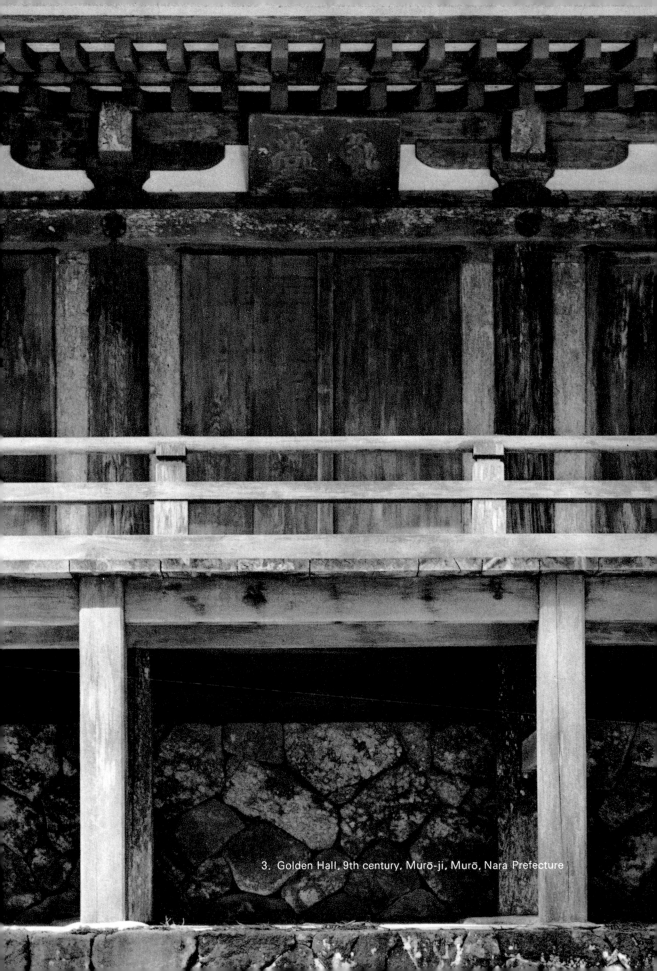

3. Golden Hall, 9th century, Murō-ji, Murō, Nara Prefecture

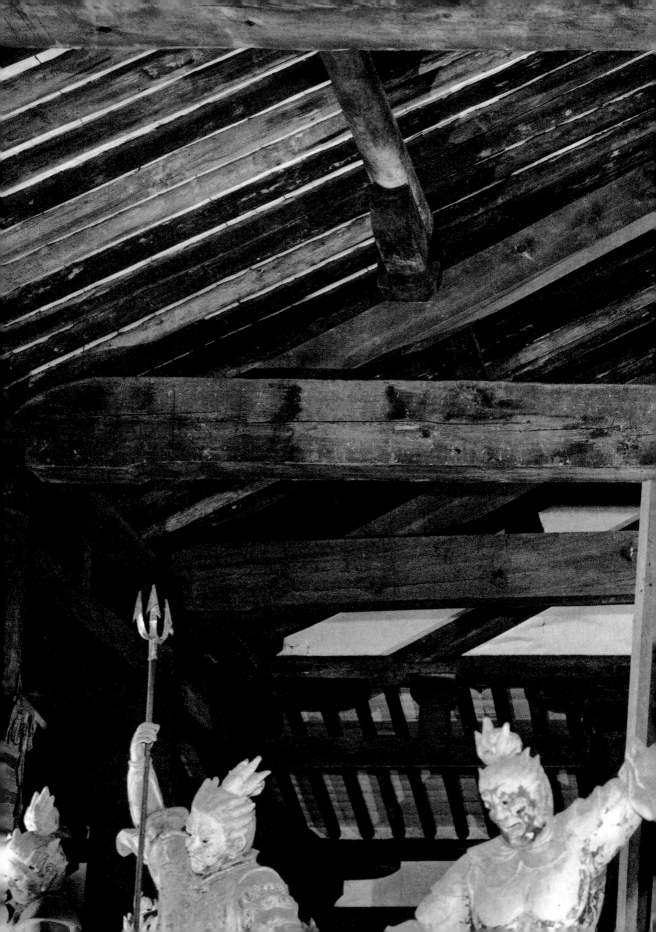

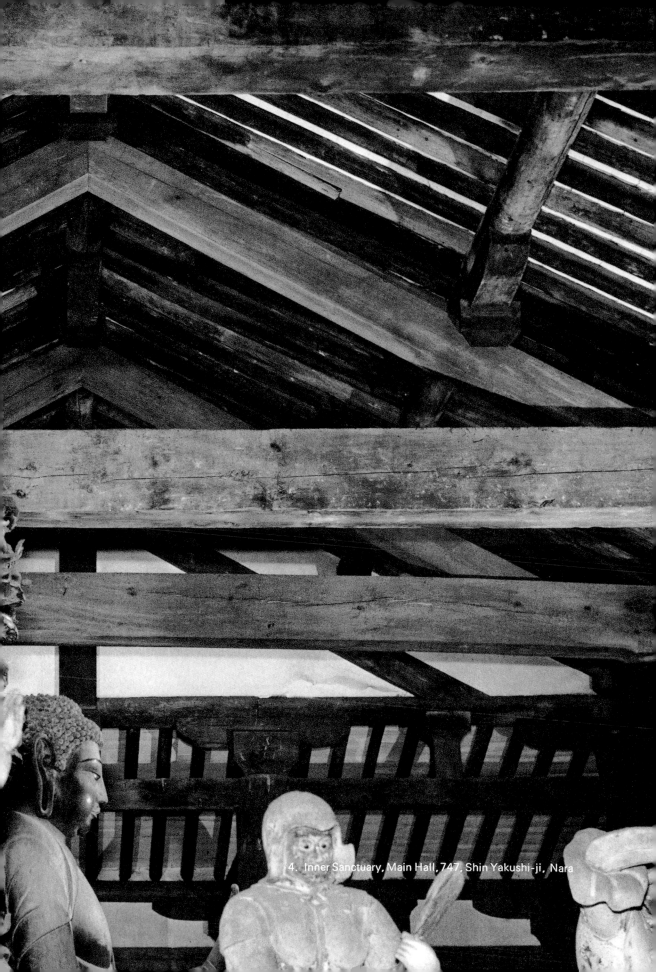

4. Inner Sanctuary, Main Hall, 747, Shin Yakushi-ji, Nara

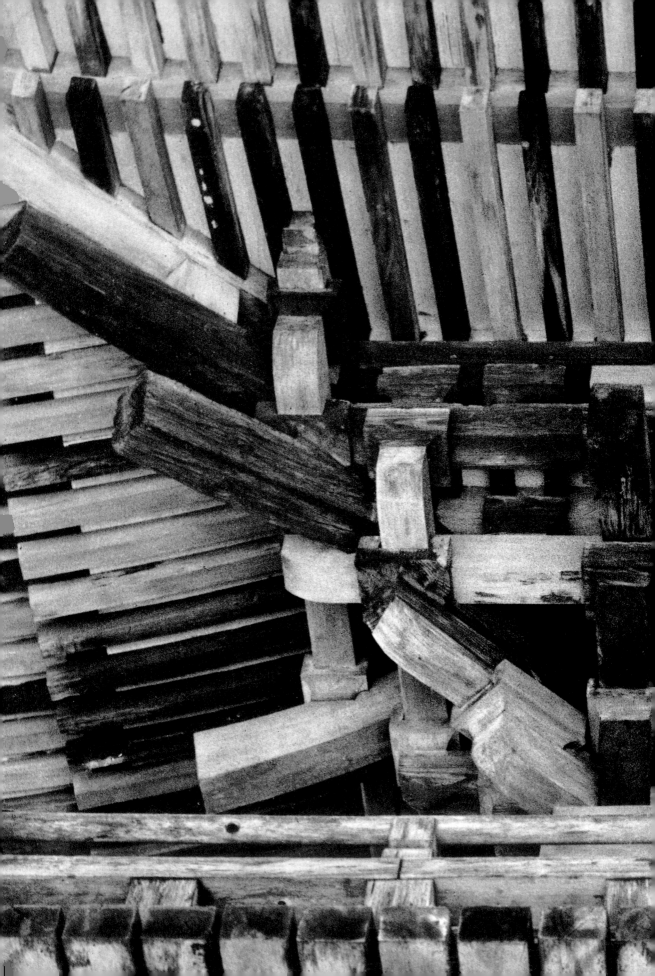

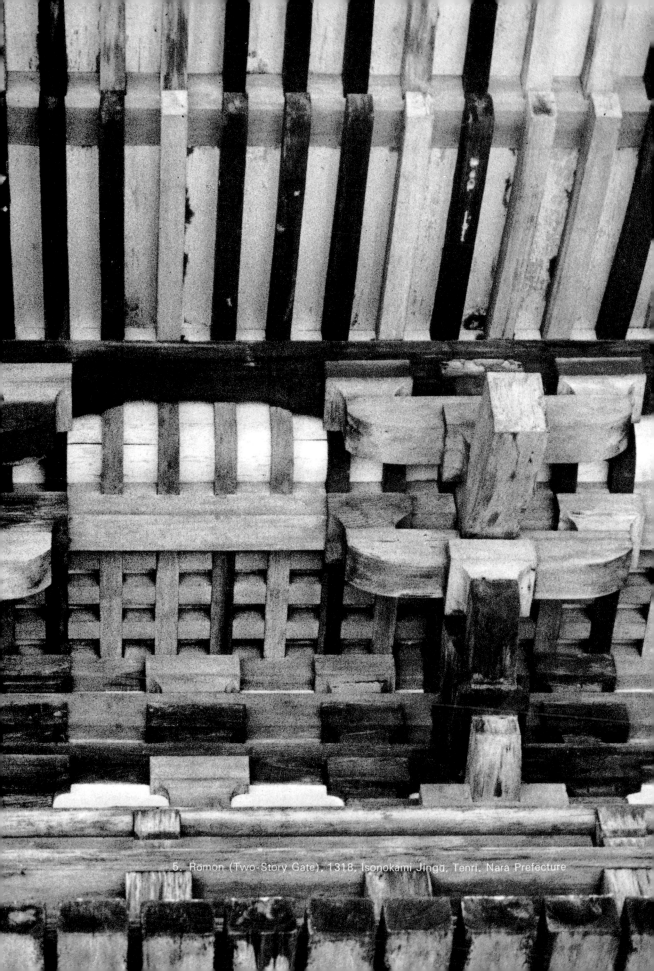

5. Romon (Two-Story Gate), 1318, Isonokami Jingū, Tenri, Nara Prefecture

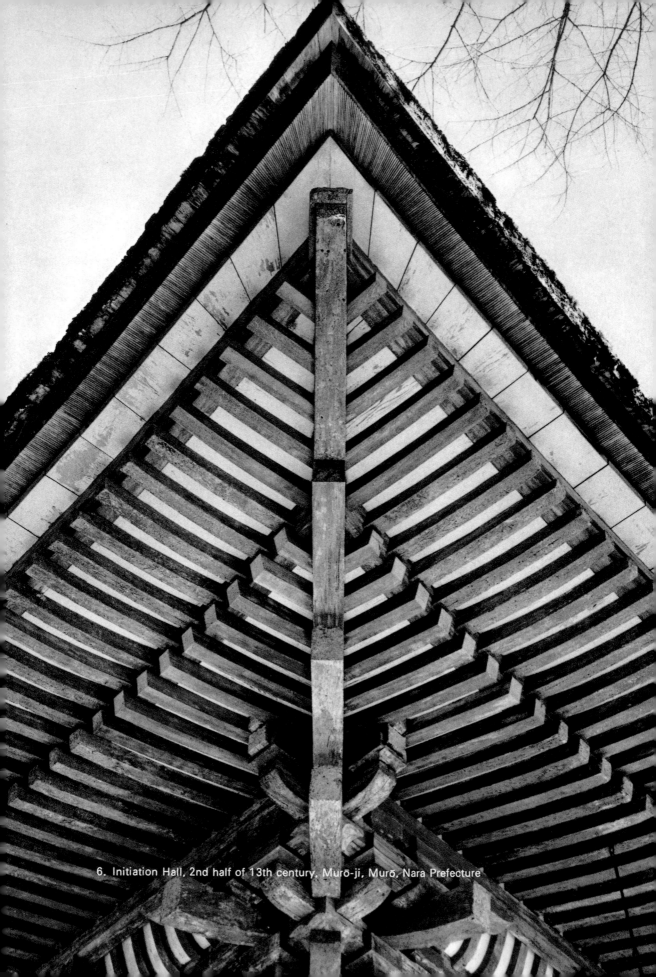

6. Initiation Hall, 2nd half of 13th century, Murō-ji, Murō, Nara Prefecture

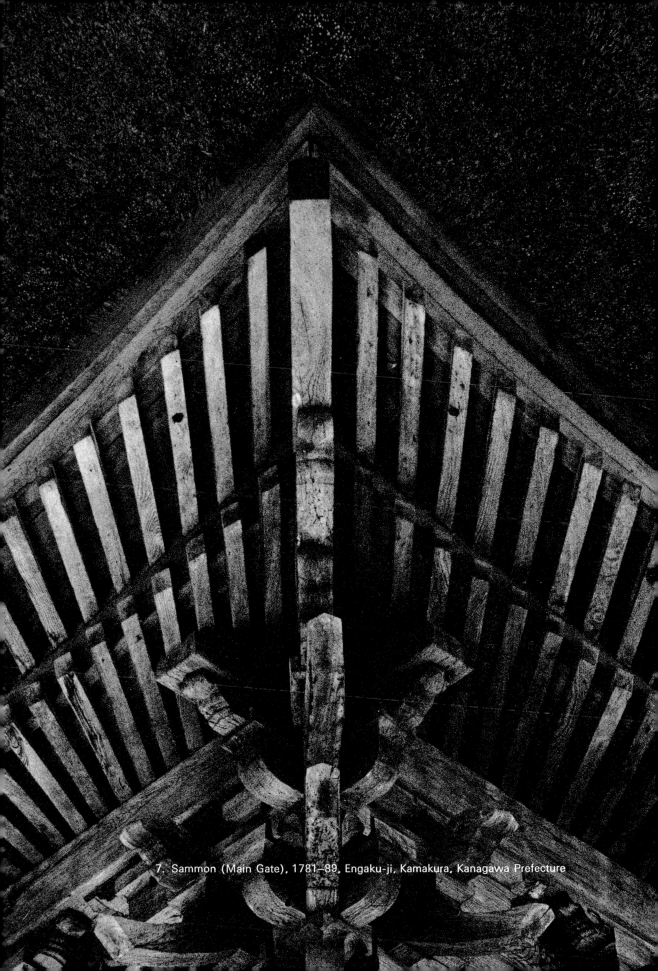

7. Sammon (Main Gate), 1781–89, Engaku-ji, Kamakura, Kanagawa Prefecture

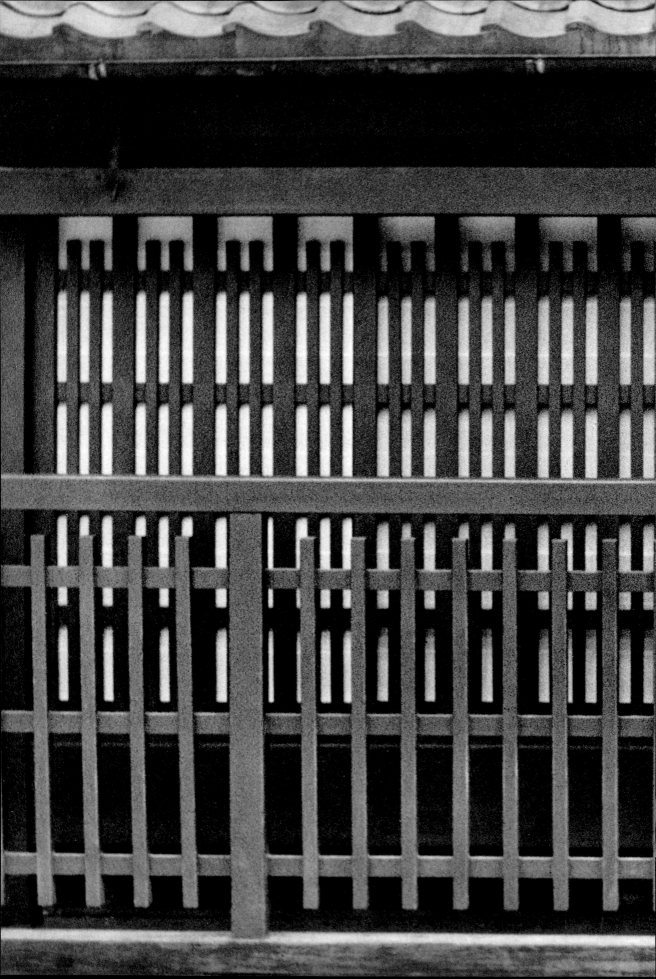

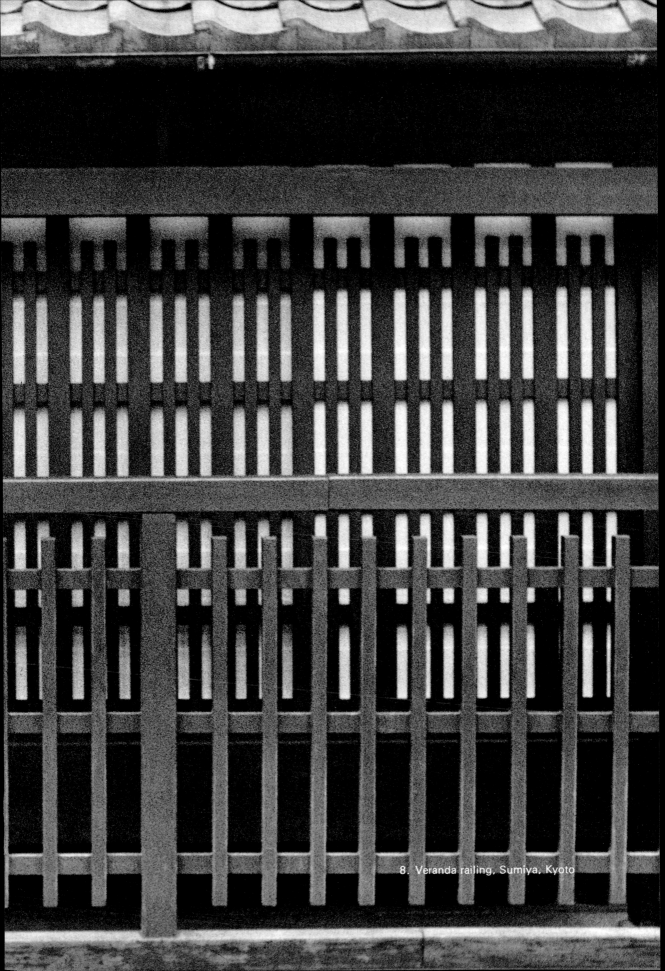

8. Veranda railing, Sumiya, Kyoto

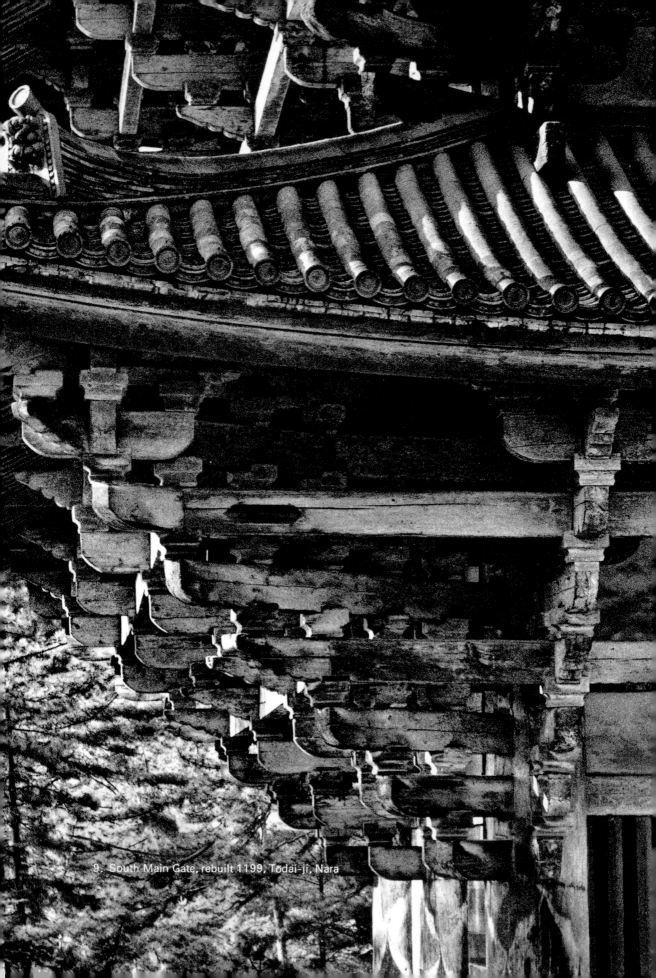

9. South Main Gate, rebuilt 1199, Tōdai-ji, Nara

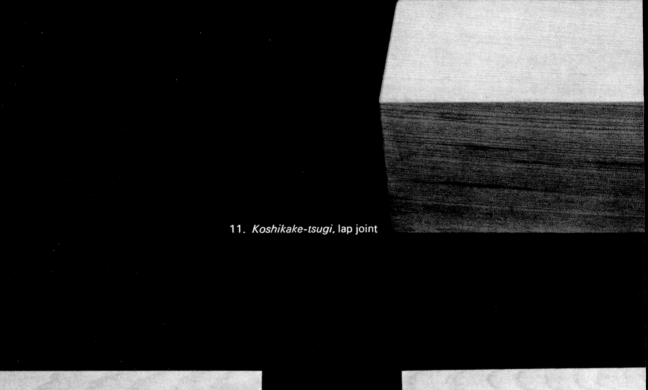

11. *Koshikake-tsugi*, lap joint

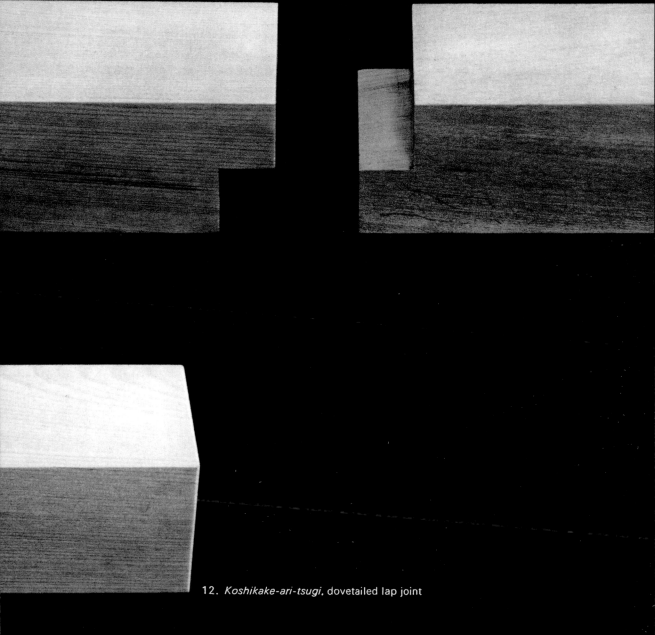

12. *Koshikake-ari-tsugi*, dovetailed lap joint

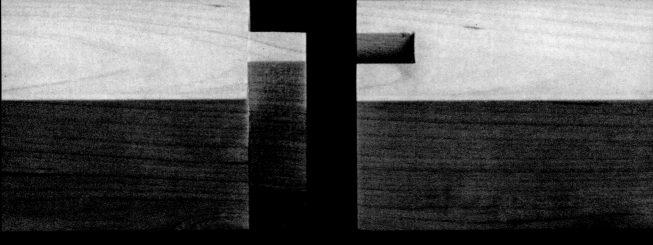

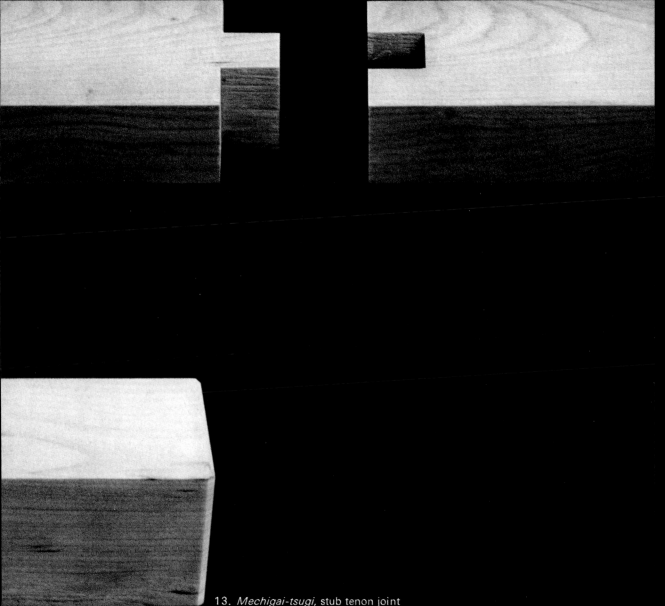

13. *Mechigai-tsugi,* stub tenon joint

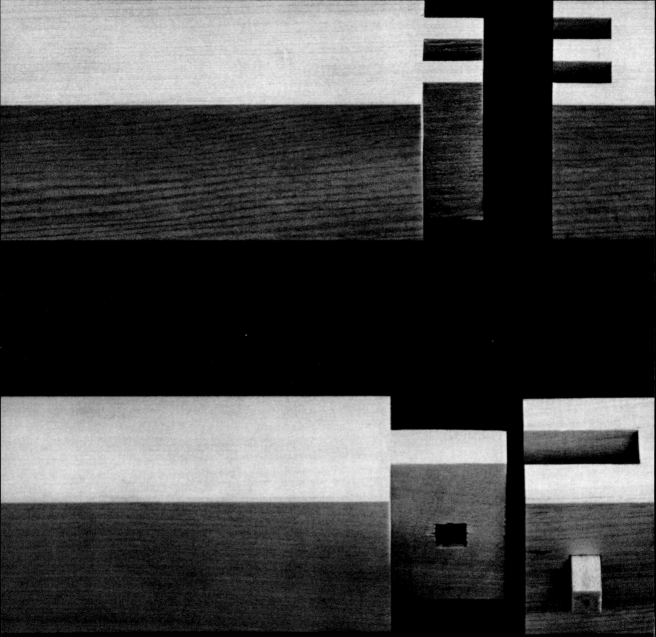

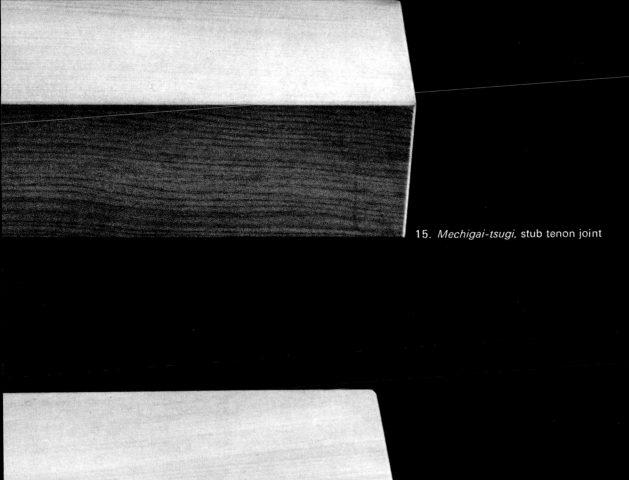

15. *Mechigai-tsugi,* stub tenon joint

16. *Mechigai-tsugi,* stub tenon joint

17. *Koshikake-kama-tsugi,* lapped gooseneck mortise and tenon joint

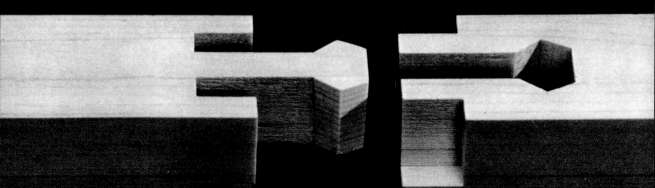

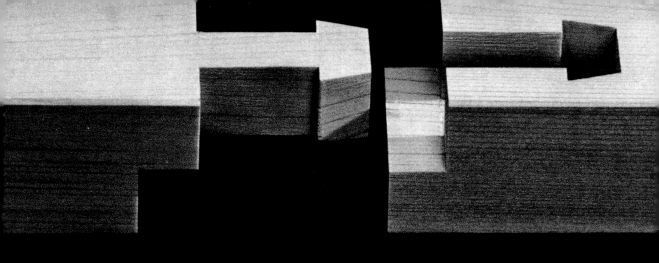

Mechigai-koshikake-kama-tsugi, lapped goose-
mortise and tenon joint with stub tenons

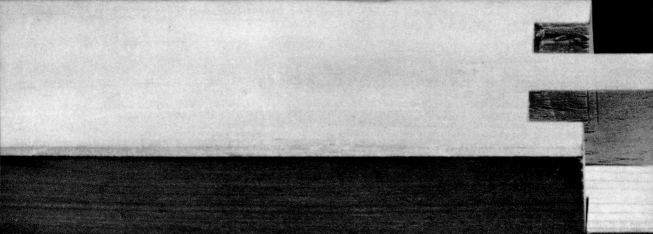

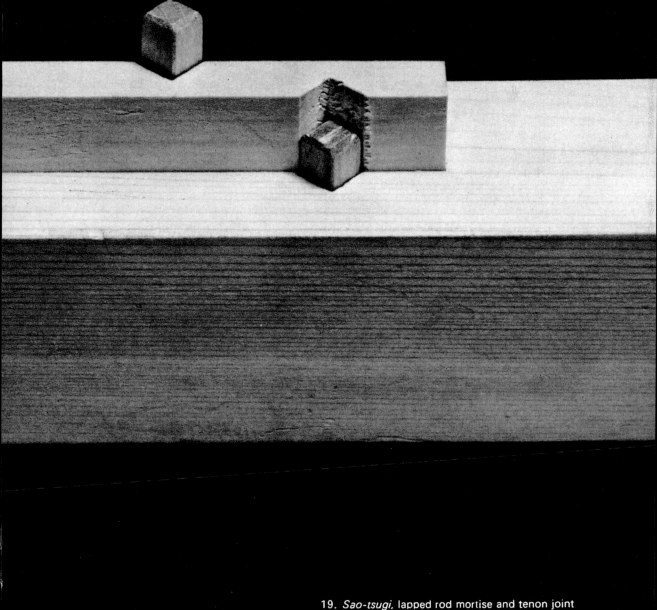

19. *Sao-tsugi*, lapped rod mortise and tenon joint

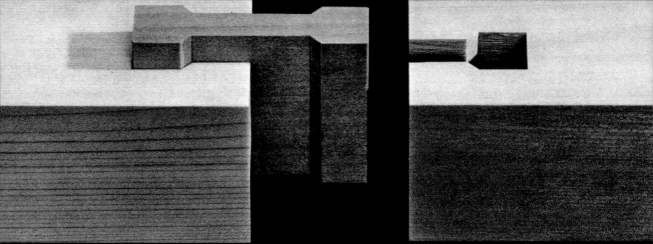

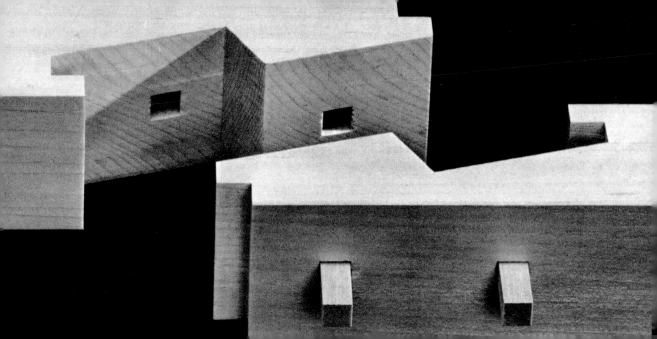

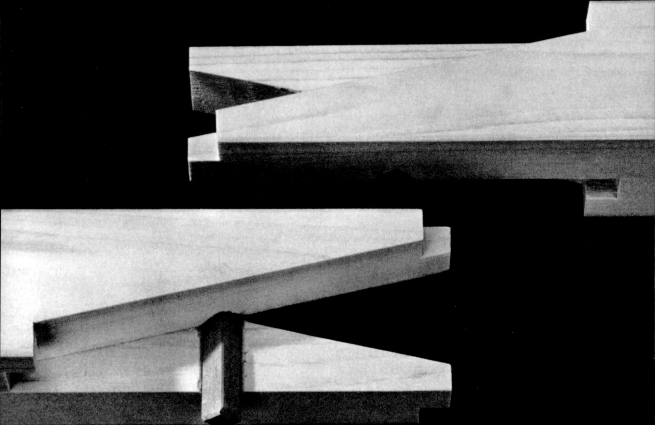

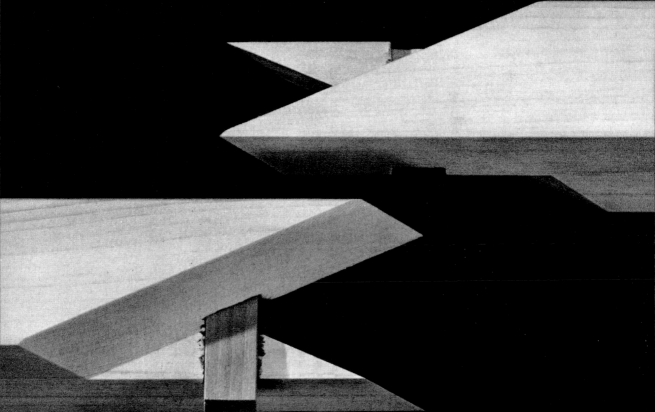

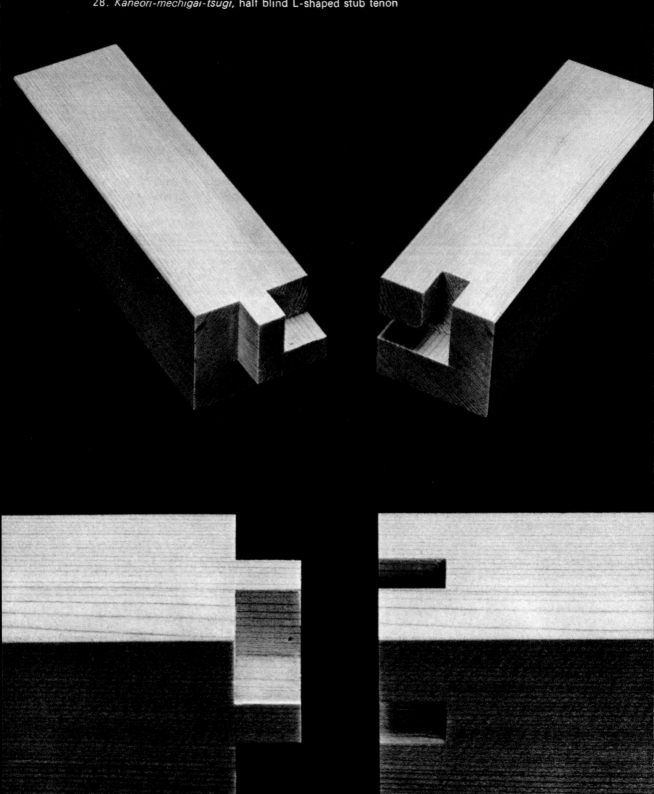

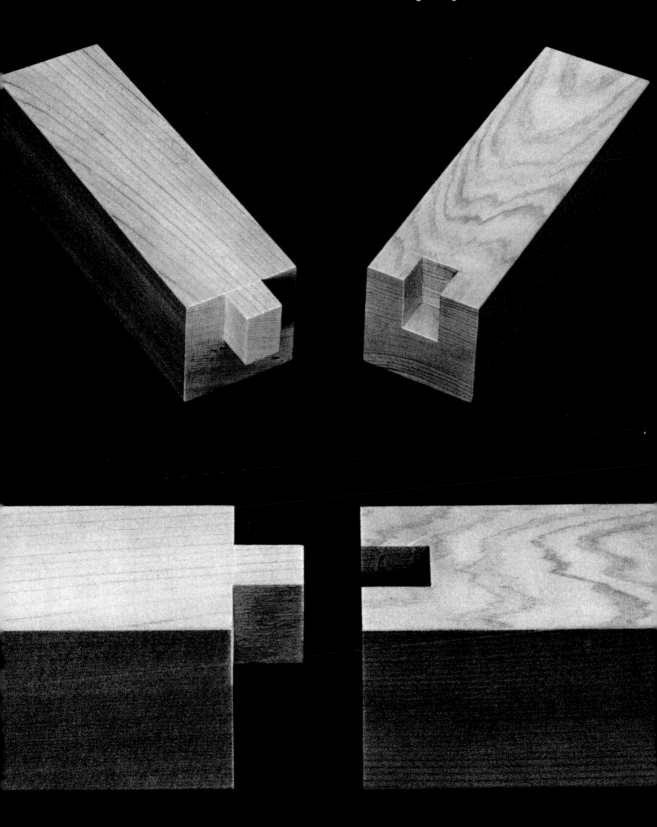

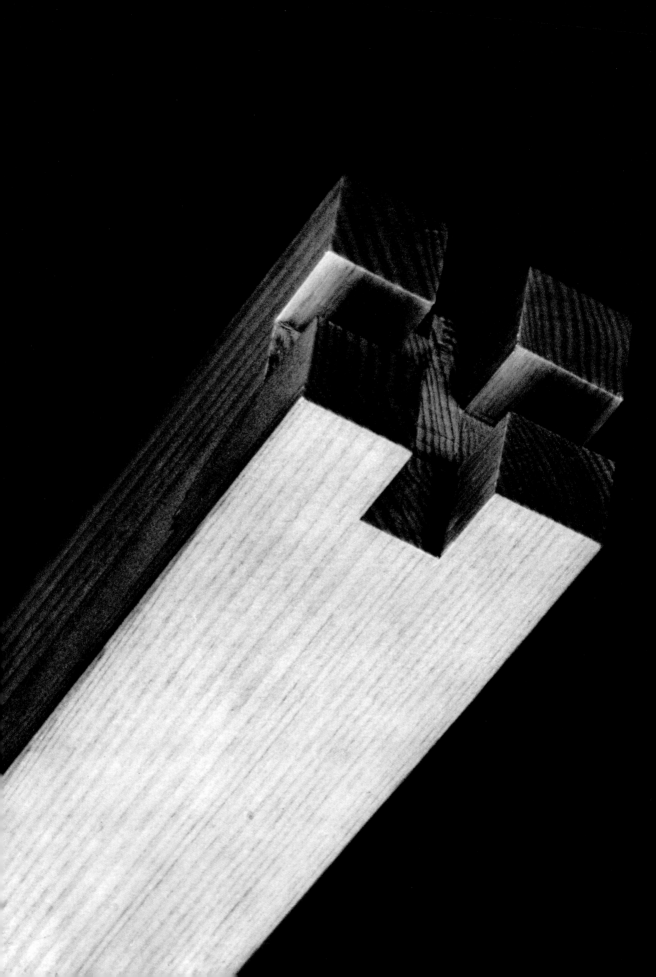

Jūji-mechigai-tsugi, cross-shaped stub tenon

31 (top). *Kakuhozo-imo-tsugi*, blind square stub tenon
32 (bottom). *Ōgihozo-imo-tsugi*, blind fan-shaped stub tenon

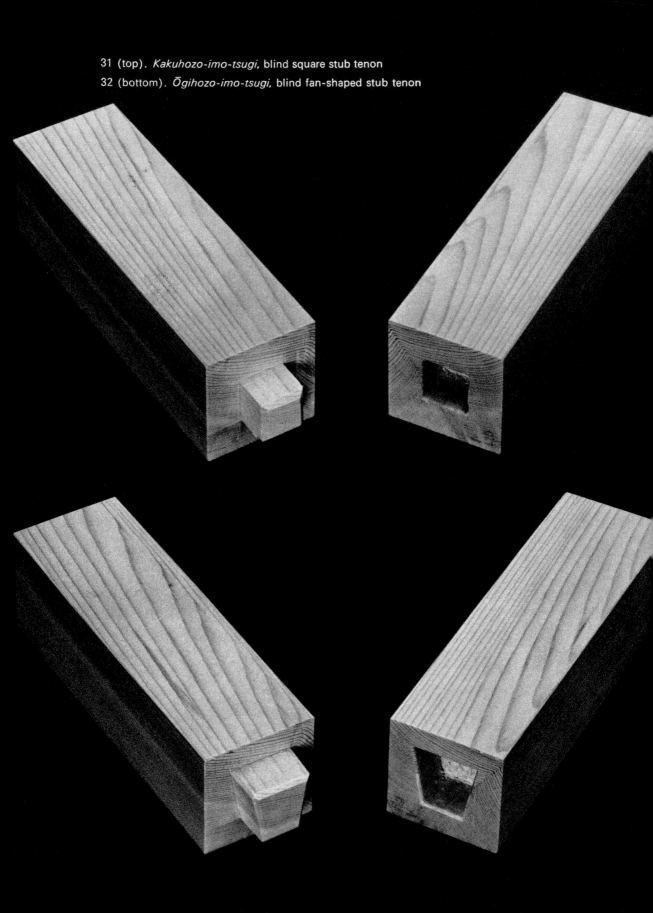

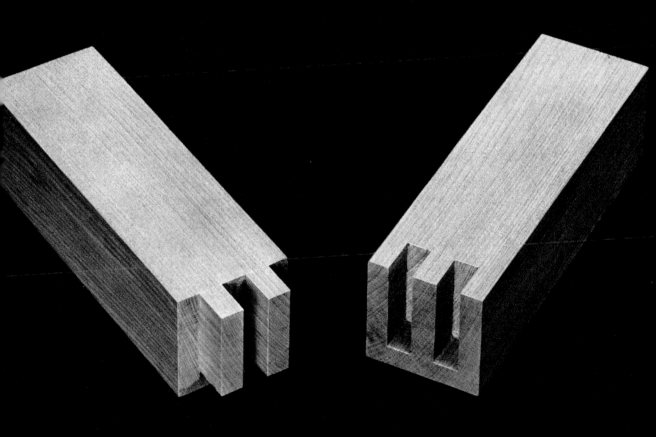

34. *Hako-mechigai-tsugi,* blind U-shaped stub tenon

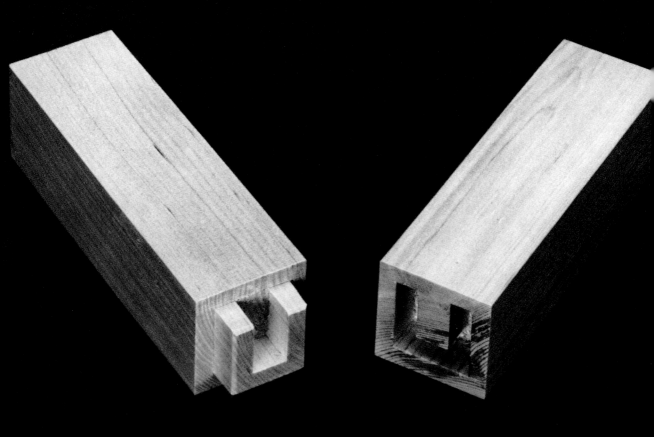

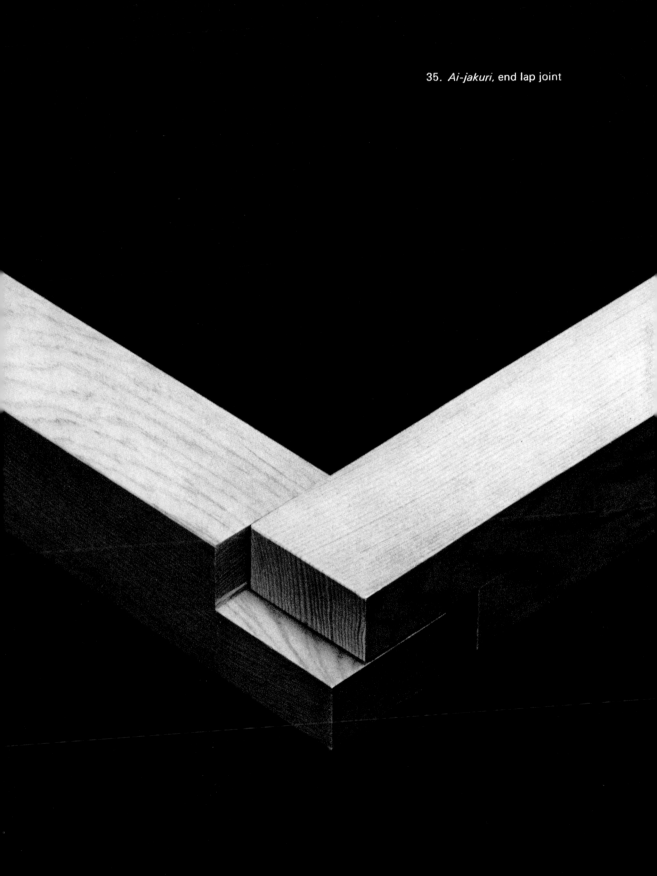

35. *Ai-jakuri,* end lap joint

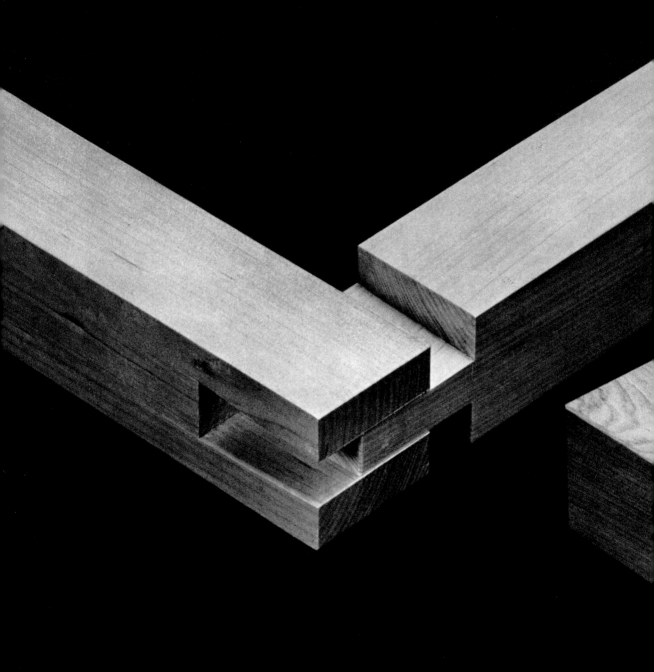

36. *Sammai-gumi,* open slot mortise

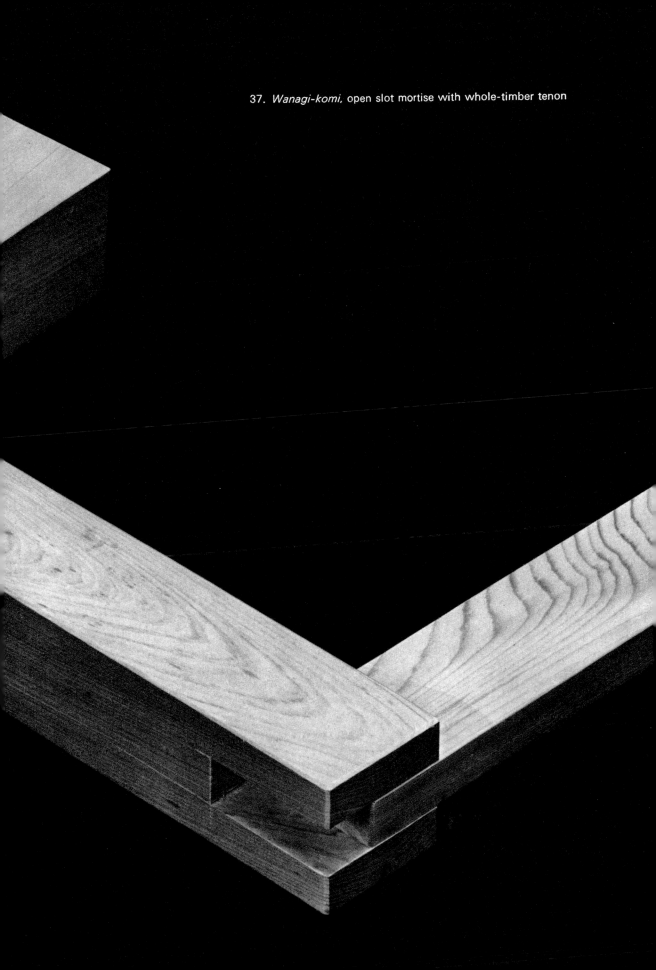

37. *Wanagi-komi,* open slot mortise with whole-timber tenon

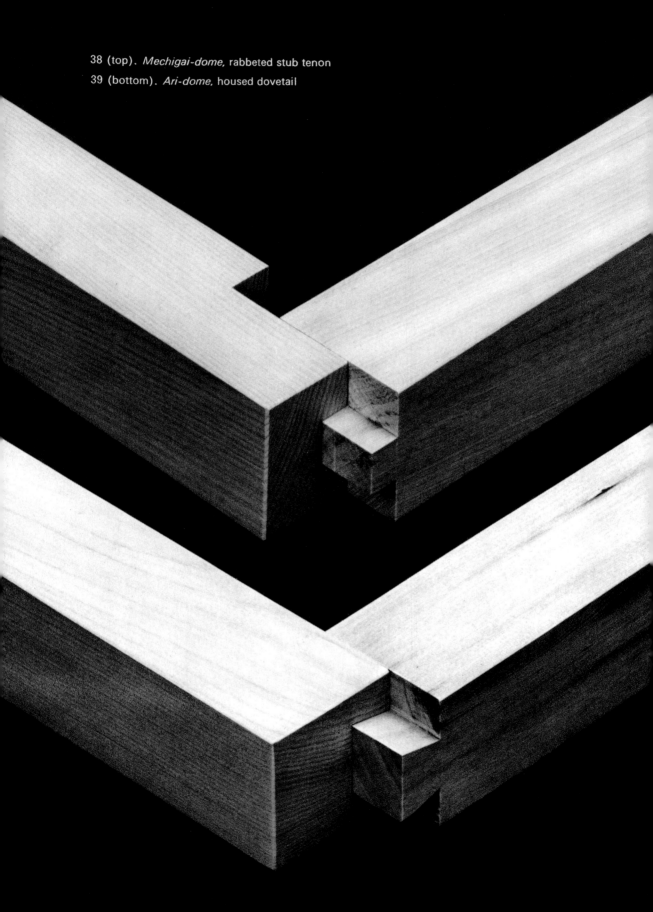

38 (top). *Mechigai-dome,* rabbeted stub tenon
39 (bottom). *Ari-dome,* housed dovetail

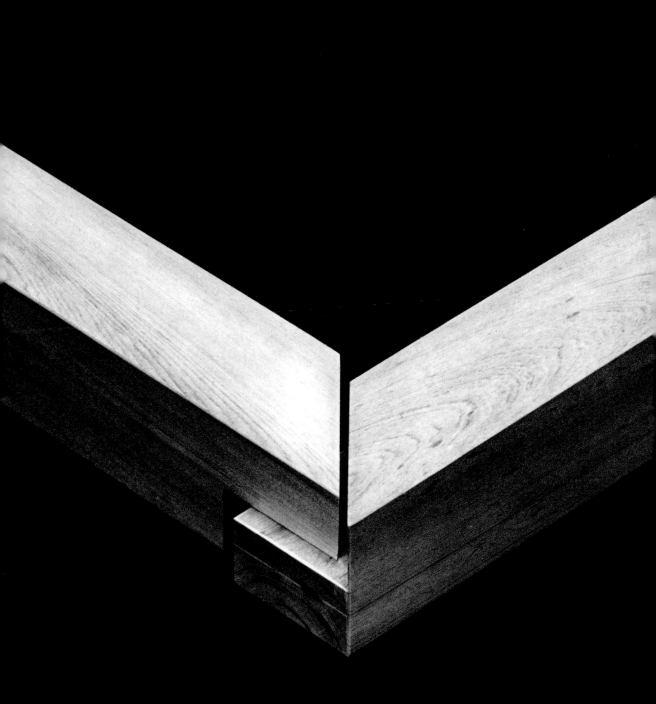

40. *Ō-dome*, mitered open mortise

41. *Hako-dome*, rabbeted tenoned miter joint

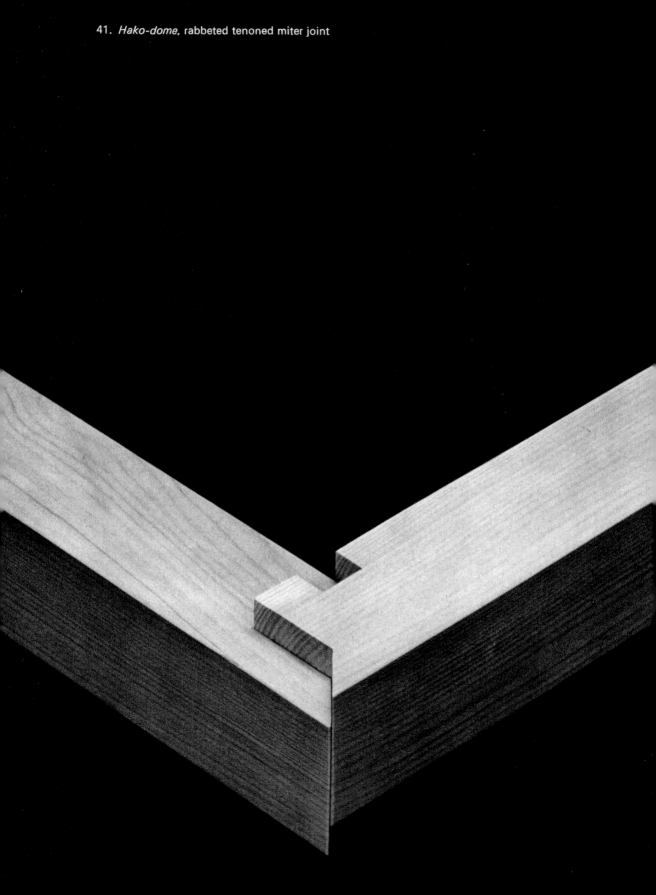

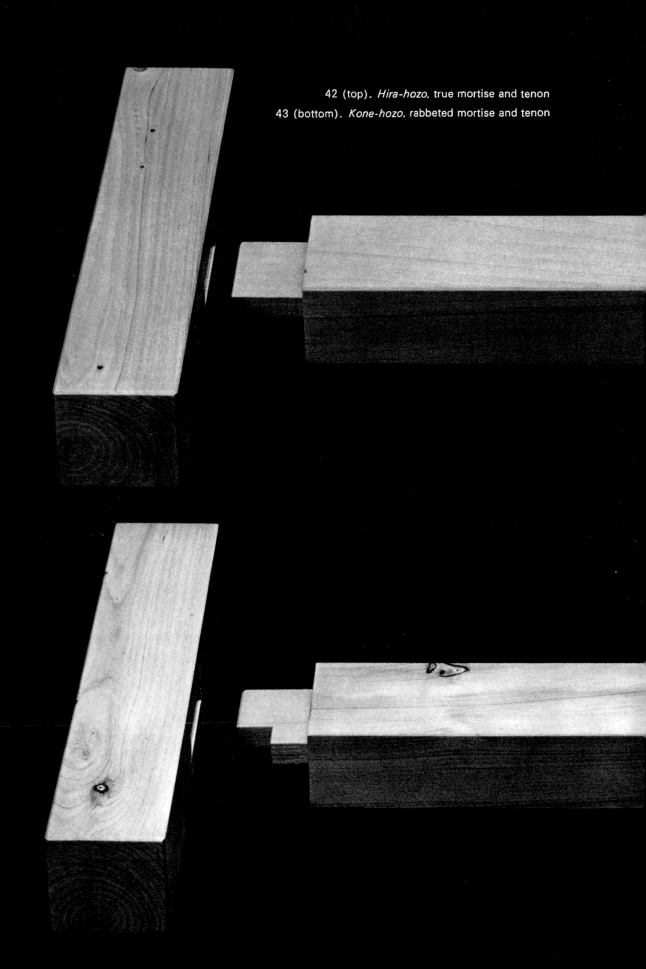

42 (top). *Hira-hozo,* true mortise and tenon
43 (bottom). *Kone-hozo,* rabbeted mortise and tenon

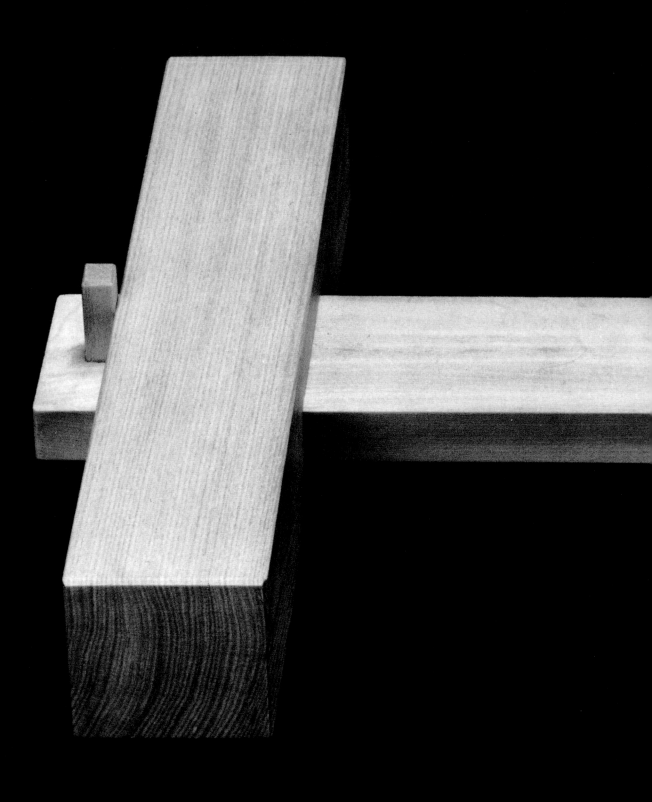

44. *Hana-sen,* external draw pin joint

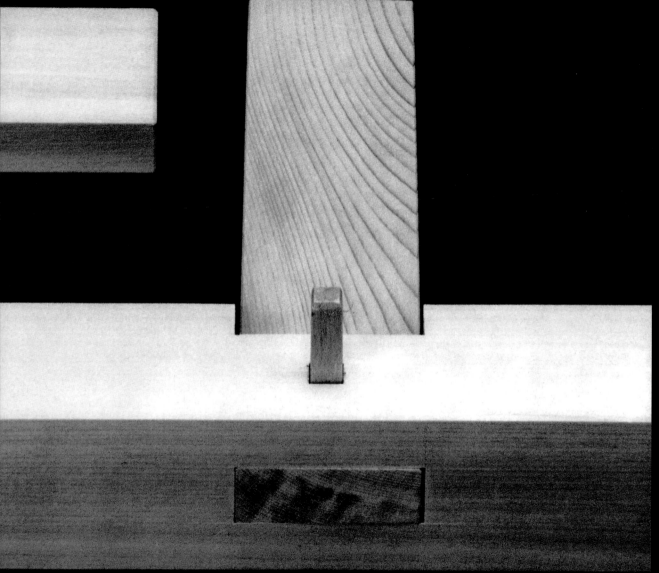

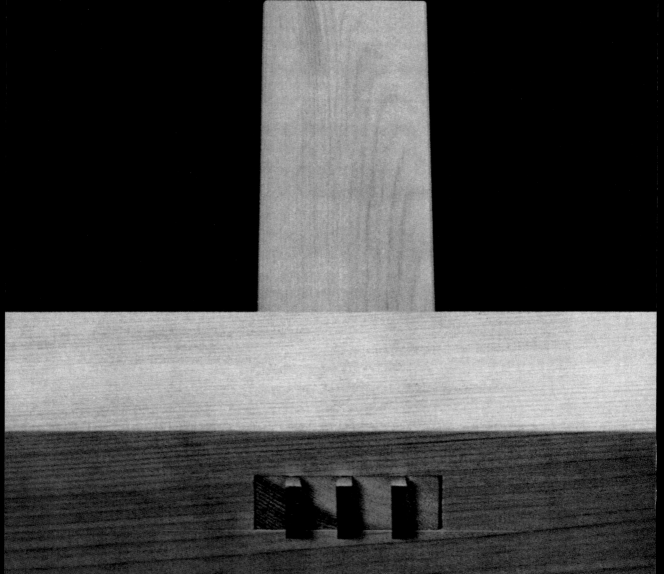

47. *Jigoku-kusabi,* wedged blind tenon

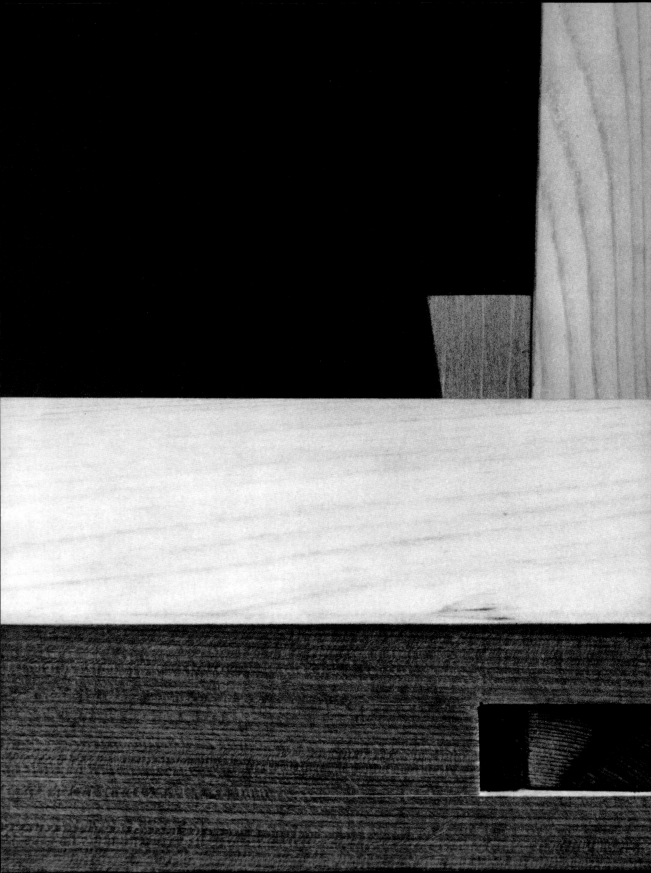

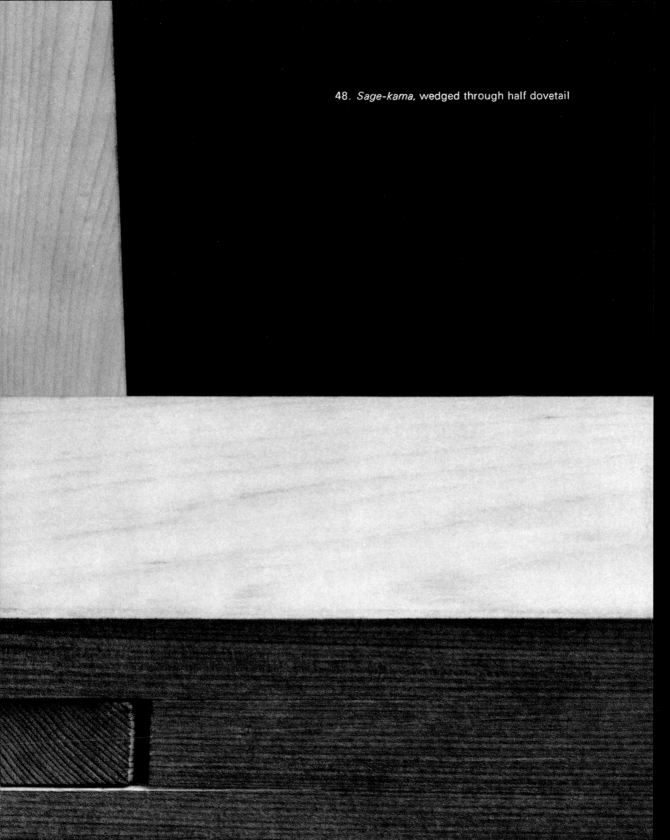

48. *Sage-kama,* wedged through half dovetail

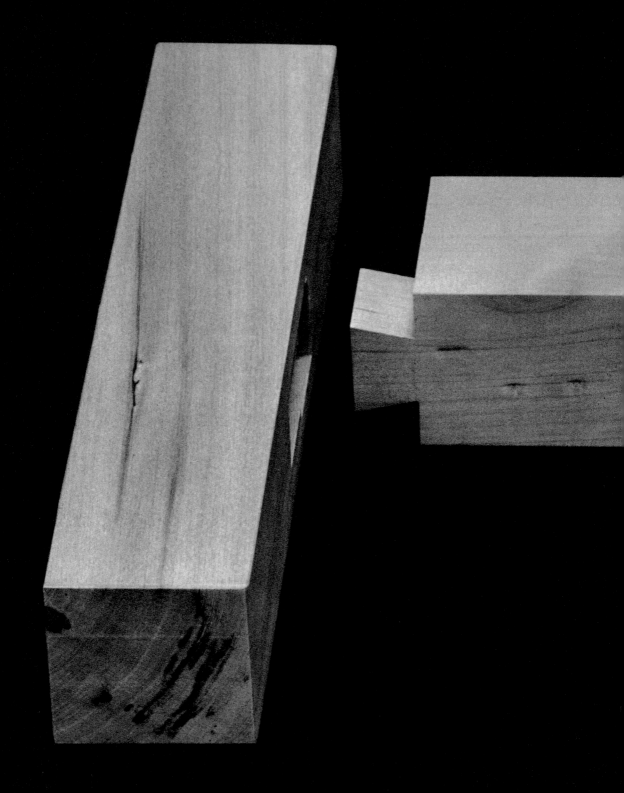

49. *Ari-otoshi,* housed dovetail

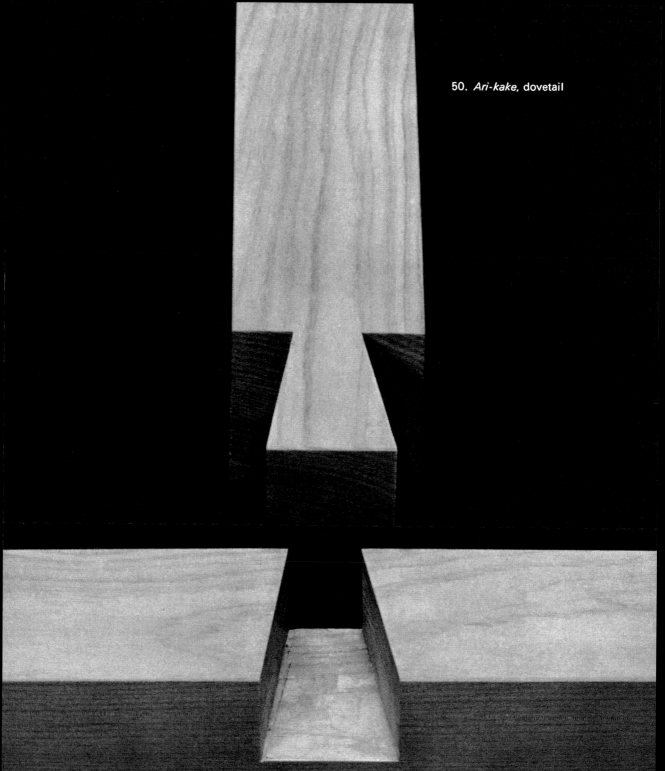

50. *Ari-kake,* dovetail

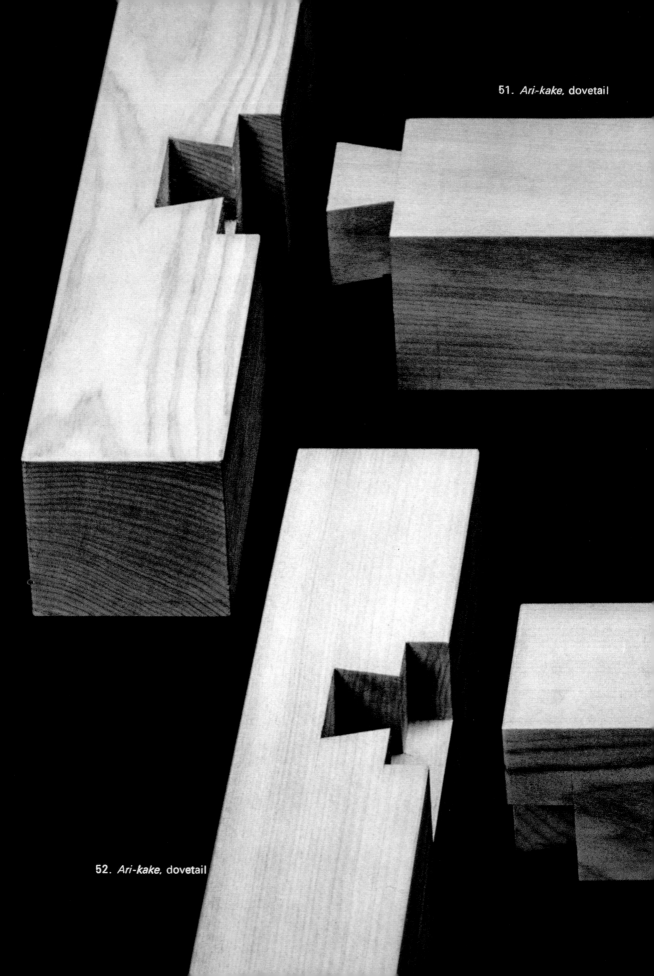

51. *Ari-kake,* dovetail

52. *Ari-kake,* dovetail

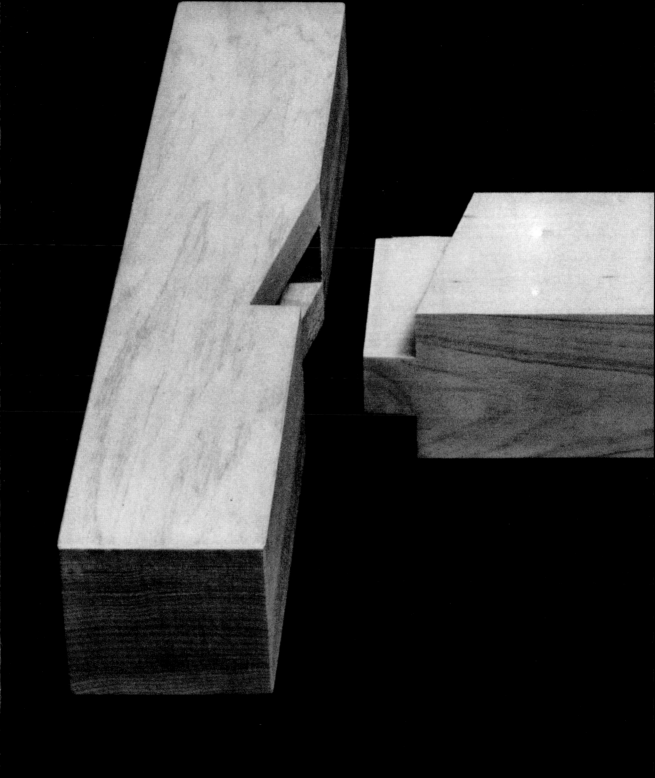

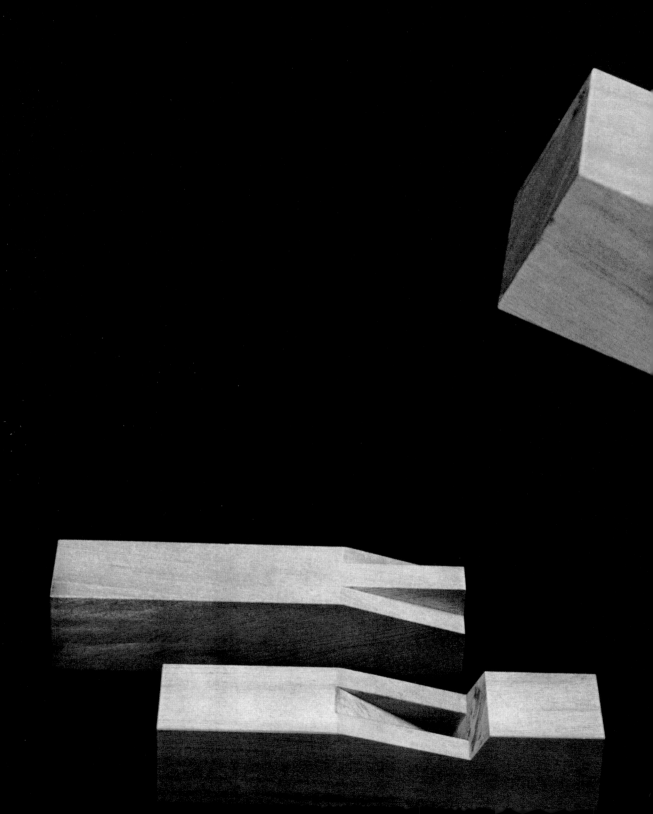

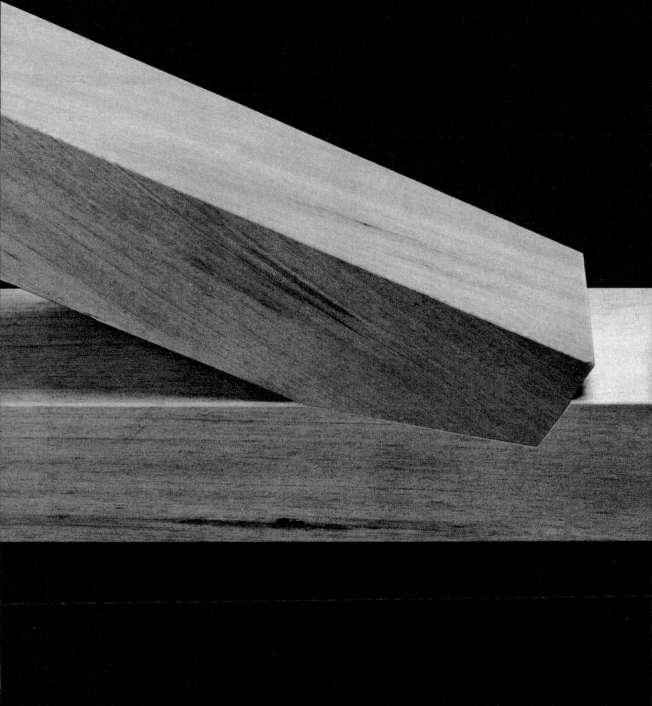

54. *Kashigi-ōire*, notched mortise and tenon

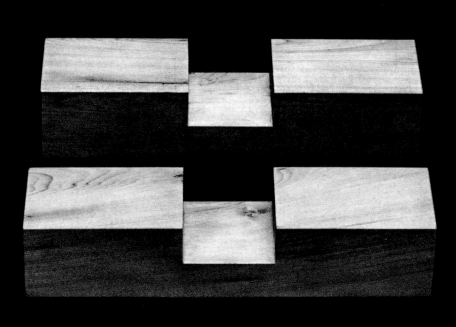

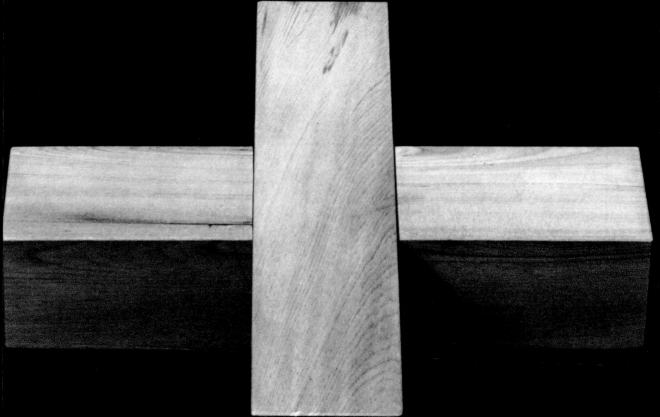

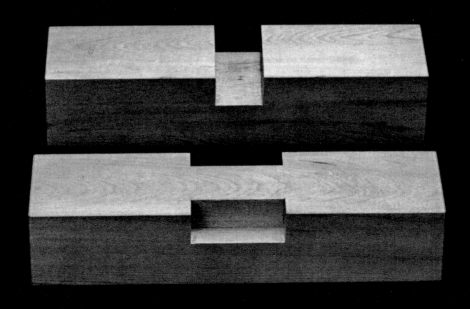

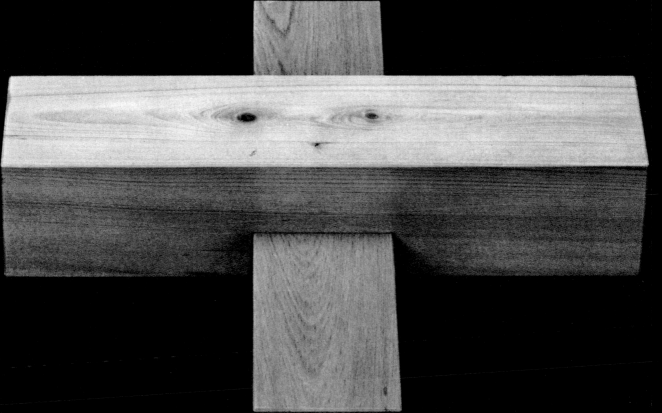

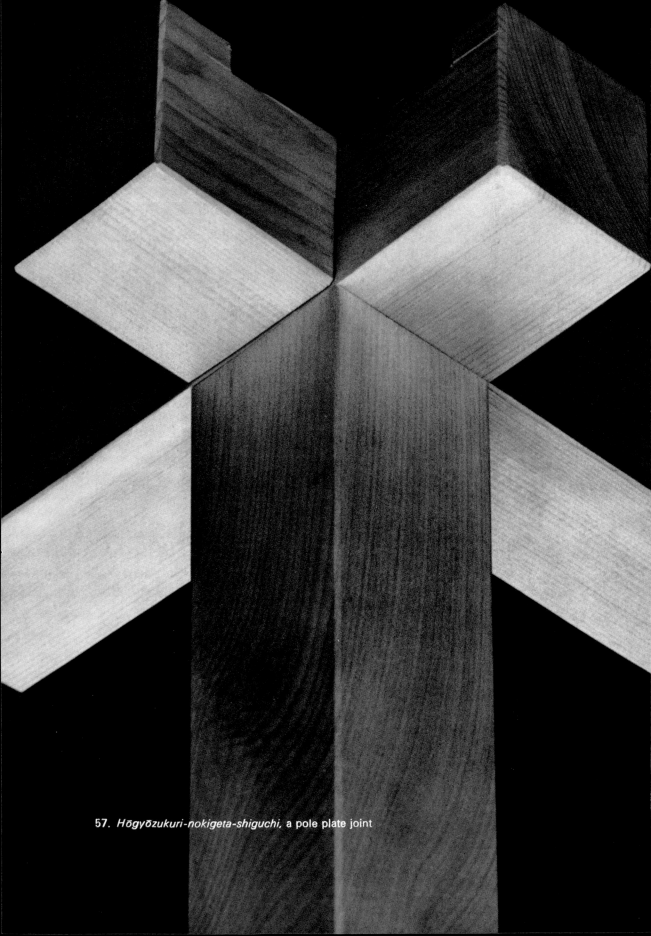

57. *Hōgyōzukuri-nokigeta-shiguchi,* a pole plate joint

2. Functions of Japanese Joinery

Wood Construction Most people believe that wood is weaker than either steel or concrete. But if we compare strength by volume weight even white cedar, which is considered weak among woods, has a tensile strength about four times as great as that of steel and its resistance to compression force is about six times as great as that of concrete. Perhaps only in its vulnerability to insect attack is wood inferior to steel, concrete, or stone.

In general, people seem to feel that the combustible nature of wood is a great defect, and yet fires in wooden structures rarely result in human injuries. A few years ago there were hotel fires in the hot-spring resorts of Minakami, in Gumma Prefecture, Arima, near Kobe, and Bandai, in Fukushima Prefecture; and each fire resulted in more than thirty deaths. All those fires were in first-class hotels, ferroconcrete structures. But during the same period there was also a fire at the Koyasukyō hot-spring resort, in Akita Prefecture, in which twenty-two houses were burned to the ground. There were no deaths or injuries in that fire. Here we have an obvious paradox: because of wood construction twenty-two buildings were destroyed, instead of a single ferroconcrete structure, and yet because of wood construction there were no casualties. Obviously, it behooves us to reconsider the value of wood as a structural material.

Because wood is a natural material, it is responsive to the changes of nature; for example, wood contracts or expands with fluctuations in humidity. This responsiveness is supposed to be particularly noticeable in *azekura*, or log-cabin style, construction. The eighth-century Sutra Repository of the Nara temple Tōshōdai-ji (Fig. 1) is an excellent example of the *azekura* style, but perhaps the most famous *azekura* building in Japan is the Shōsō-in, the eighth-century treasure repository at Tōdai-ji, in Nara.

It has long been claimed that an even humidity is maintained naturally in *azekura* structures because the unchinked joints open and close as the wood contracts or swells in response to external humidity levels. However, when humidity levels inside and outside the Shōsō-in were carefully monitored and recorded over a long period, this claim was proved to be nothing more than wishful thinking. And yet, many people who own dressers made of paulownia, a wood particularly responsive to changes in humidity, have found it all but impossible to open their dresser drawers during the

rainy season, when humidity is unusually high. There are even flood records mentioning that people who had suffered almost total losses discovered that articles stored in paulownia dressers survived intact because the drawers had swelled tightly shut.

Unfounded claims notwithstanding, it is indeed probable that the treasures in the Shōsō-in have so well survived some twelve hundred years of storage because they were in a wooden structure. The artificial nature of steel and concrete may actually render them less able to preserve perishable materials. In fact, in many instances concrete storage facilities may be far less desirable than simple wooden structures. In Japan we often hear complaints from residents of ferroconcrete buildings: complaints ranging from cracking walls and walls and windows that sweat excessively to closets so invaded by mold and mildew that they can be used only if a light is kept burning in them. Undoubtedly, many of these complaints arise not only because the residents are unaccustomed to living in ferroconcrete apartments but also because living conditions in ferroconcrete structures are noticeably inferior to those in wooden structures. Certainly in Japan, with its wide variations in humidity and temperature, wooden structures, which respond to those changes, are the most comfortable to live in.

In answer to those who would insist that wood's vulnerability to decay makes it an undesirable construction material, I would point out that the Shōsō-in has survived more than twelve hundred years and Hōryū-ji's Golden Hall has survived almost exactly thirteen hundred years, and both are still in excellent condition. It is obvious that well-designed and well-constructed wooden buildings that are well cared for can survive indefinitely. If we wanted to search further for deficiencies in wood as a structural material, we could point out its inherent biological insufficiencies: the girth and height of a tree are limited. And yet, these limitations can be overcome through construction and joinery techniques and even through use of synthetic bonding materials.

By and large, wood compares very favorably with other construction materials. Because the many virtues of wood far outweigh its defects, wood construction has been esteemed by architects for a very long time. In Japan, in particular, because abundant forests made it economical, wood was highly favored as a structural material despite the technical problems sometimes presented in trying to coax wood to assume the shapes we consider typical of Japanese architecture. Perhaps the most important of the special qualities of wood is the ease with which it can be worked and shaped. No doubt this quality has contributed to the widespread preference for wood in constructing everything from houses and furniture to aircraft and ships. Few other materials are as adaptable as wood.

Perhaps we should not consider it a fault, but one shortcoming of natural materials like wood is that they have unforeseen defects: instead of being perfectly uniform, like metal alloys, for instance, natural materials retain their individualistic characters to a very great degree. Some timbers with knots, for example, are extremely weak, while other timbers with nearly identical knots are as strong as clear lumber.

The measurable strength of a particular variety of wood varies according to the tests applied; for example, in crushing tests oak is nearly 2 1/4 times stronger than long-leaf pine, yet in tests of compression across the grain oak and long-leaf pine are of exactly the same strength. If we exclude the strongest woods used in construction, white oak and hickory, as well as the weakest, white pine and white cedar, the rest of the woods used are of roughly the same strength when all the tests are averaged out.

All carpenters are aware that the strength of a timber, no matter what its variety, will vary with the direction of stress. An extremely heavy load can be placed directly on the head of a stout post, while if the same load is placed directly in the center of a beam of the same dimensions that is supported only on either end, the beam will soon sag or possibly even break, although it may be quite capable of carrying the same load without deformation if that load is distributed evenly along the full length of the beam.

The deformation of a wooden structure is a very slow process. Displacement occurs gradually, when the slack or play in joints is taken up as a structure settles. No matter how exacting a carpenter is in his work, such displacement is unavoidable when splicing and connecting joints are used. Because there is almost no play in joints that are glued and nailed together, they are not subject to much distortion and displacement resulting from slippage or settling.

Since slack and play are inevitable in unreinforced handcrafted joints, a carpenter must anticipate the eventual amount of displacement and compensate for it at the time of construction. In truss construction, for example, if tie beams do not have a camber equal to about one one-hundredth of their span, they will not be true when the combined load of the truss and roof takes up all the play in the splicing and connecting joints. Many techniques have been developed for making joints fit tightly together and for reducing the amount of play in them. For example, when making a tenon joint the careful carpenter will make sure that he cuts his mortise and tenon exactly the same size, frequently by simply cutting on the scribed lines on the mortise and beside those on the tenon. The result is a tenon that is a bit more difficult to start into the mortise and considerably more difficult to drive home than a loose-fitting tenon would be. But a tight-fitting tenon, which virtually eliminates excess play in a joint, is well worth the extra care and effort it requires.

When an external force is applied to a splicing or connecting joint, its energy is often reduced through the internal friction of the joint. During an earthquake, for example, a wooden structure will sway and make disturbing noises; but in general the noises are caused only by the members of the joints shifting against each other in response to the external force. Much of the energy of an earthquake is absorbed in these noisy joints; hence, wood construction with its many joints is unexpectedly resistant to earthquake damage. Although it will shake a great deal, a wooden house built on solid ground does not resonate with an earthquake—that is, amplify its intensity by vibrating at nearly the same frequency—because it has a longer period of vibration. Through deflection and friction in its joints, a wooden house absorbs the high-amplitude energy occurring at the beginning of an earthquake, which as a result means that a wooden structure is actually quite safe.

One characteristic that can be either a strength or a weakness in wood as a structural material is its sensitivity to humidity. The moisture content of a living tree is generally well above thirty percent. After a tree is felled and dressed it is allowed to dry, preferably in the air, and its moisture content decreases to between twelve and nineteen percent, depending on the original moisture content of the tree and the humidity of the air in which it is dried. Since the effects of humidity on dressed lumber vary in relation to the dimensions of a piece of wood and even the method used to dry and season it, it is not unusual for a carpenter who has cut his joints too far in advance to find

that their members have been so affected by humidity in the meantime that they simply will not fit together properly.

We know that a hole made in a post with a small-gauge nail that is soon pulled out will close up fairly quickly if the wood is thoroughly moistened with water, because the additional moisture causes the wood fibers to swell. This principle is also useful in carpentry. When making joints, if a carpenter kiln-dries his lumber and brings the moisture content down to less than ten percent before he cuts his joints and fits them together, when the finished joints are exposed to the air they absorb moisture, bringing their moisture content up to the level of that of air-dry lumber, which is around eighteen percent in Japan. With the increased moisture content the joint members swell and, in a well-made joint, fit together so tightly that they almost become one body. In addition, if a carpenter fashions such a tight-fitting joint that it takes a great deal of force to drive the tenon home without splintering either the mortise or the tenon, or uses draw boring to bring the tenon solidly home, the result is a very well fitting joint with little play in it.

As with all living things, wood gets tired when it gets very old, and like Oliver Wendell Holmes's "wonderful one-hoss shay," ancient joints will sometimes collapse simply because of age. But we have seen both "old" and "young" joints break because sudden high, arid temperatures dried them out too much.

Splicing and Connecting Joints Trees have yielded very long beams and pillars, such as those we find at Tōdai-ji in the Daibutsu-den, or Great Buddha Hall, the largest wooden structure in the world. In its construction, the British Columbia Pavilion at EXPO '70 used sequoia posts fifty meters long (about 166 1/2 feet). I learned that these enormous posts came from trees that had stood some seventy meters high (about 233 feet) in the Canadian forests. These evergreens, known variously as sequoia, giant sequoia, redwood, giant redwood, or simply big tree, commonly grow to a height of nearly one hundred meters, or over three hundred feet. During the Mesozoic Era, when the climate was generally benevolent, even larger trees flourished.

In recent years it has become increasingly difficult to obtain such huge posts and beams. This is chiefly due to the facts that the remaining stands of very large trees are so scattered and so far away from established logging operations that it has become both difficult and unprofitable to harvest them and that sawyers find it more economical to market lumber in a few standard lengths. It has, therefore, become common to create large posts and beams by splicing shorter timbers. Although it is not pointless to use the very long single beams favored for ridgepoles in much Japanese temple construction, in practice, a single long beam is not necessary if splicing joints, or *tsugite,* are sound and well made.

Most splicing joints must be reinforced and the simplest way to reinforce a joint is with iron or steel, by nailing it together; however, joints are also commonly reinforced with screws, bolts, and iron fish plates. New methods of using iron and steel and the new high-polymer adhesives to reinforce splicing joints have been developed recently. Some of the new adhesive agents are so much stronger than wood fibers that when a glued article breaks it breaks not at the glued joint but somewhere else. Before the development of these strong modern adhesives, Western carpenters and cabinetmakers relied primarily on animal-hide glues and Japanese carpenters relied on rice-based

pastes, animal and resin glues, and lacquer. Because none of these adhesive agents is particularly strong, carpenters were never able to depend on them for major construction.

The most basic joint for splicing is the butt joint, which in Japan is classified as a scarf joint; and the simplest of all butt joints is the straight end butt. This joint is so plain and simple, however, that it is difficult to classify it as a true splicing joint. By far the majority of splicing joints employ tenons, dowels, pins, or splines.

If the faces of an end-butt joint are cut oblique, rather than square, the contact surface is greatly increased, and when adhesives are used the increased adhesion surface strengthens the joint. Nonetheless, this joint remains unsatisfactory because after applying the adhesive it is difficult to get good, even contact over such a large area, with the result that adhesion is inevitably uneven, weakening the joint. The oblique scarf joint shown in Figure 21 is widely used in Japan as a splicing joint for roof-truss beams. This joint is a variation of the oblique butt joint, and its square-shouldered tenons not only increase the contact surface but make it more resistant to shifting and slippage.

The joints used in Japan to connect timbers at an angle, rather than end to end, are called *shiguchi*, or connecting joints. Although there are many kinds of joints for connecting two pieces of wood at an angle, the most widely used joints are of the mortise and tenon class. As with splicing joints, connecting joints must be fashioned so they will resist tension stress, compression force, and spiral grain twist. In general, connecting joints should be reinforced with pins, dowels, metal straps, or an adhesive agent; however, not only the structural strength but the appearance of the finished joint should be taken into consideration. Wood shrinks in many different directions when it dries out, but it shrinks most along the parallel of the annual rings. Thus, when a carpenter joins two timbers with their grains running in different directions he must be especially careful because his joints may shrink apart or be weakened by seasoning checks as the wood dries out.

Tenon joints are not particularly effective where energy transmission or spiral grain twist are important factors in a joint's function. A joint intended to transmit or absorb energy should be of especially strong construction; however, both mortise and tenon, which would have to bear this burden, are rather small in comparison to the cross section of their members. To avoid the danger of too large a mortise or too small a tenon, either of which would result in a weak joint, the rabbeted tenon shown in Figure 43 was developed. This method of cutting the tenon not only increases the area of contact between the two members of the joint but increases the load-bearing efficiency of the joint. With posts and beams having a very large cross section, multiple-tenon joints were devised as the best method of increasing the area of contact and thus increasing the strength of the joint.

Groundsills, Posts, and Joinery The primary functions of the groundsill are to distribute evenly along the foundation the loads borne by posts, thus keeping the foundation from settling unevenly; to firmly tie all the structural posts together at their bases; and to tie a structure firmly to its foundation. A wide variety of lumber is used for groundsills, from very high grade wood, such as Japanese ground cypress, to low grades, such as larch. Because the groundsill is basically a very long beam, it normally requires

splicing joints, and they must be able to resist both compression stress and tension stress. When the groundsill is firmly tied to the foundation, lap joints or even straight butt joints can be used for splicing, since the footing that helps disperse the weight of posts provides secondary support. In addition to lap joints and butt joints, tenon joints and variations of tongue and groove joints are used to splice groundsills in Japan. However, it is necessary to make splicing joints only where the least stress will occur.

"Build a strong groundsill" is often heard in Japan. Certainly, a great deal of earthquake damage can be prevented by doing so. There is no question that the standing parts of a structure are important, particularly its posts and the connecting joints in the beams; but if its base is weak, even the strongest standing construction is weakened. With a very strong groundsill a house is less likely to collapse even if the ground opens during an earthquake.

Although it is occasionally necessary, splicing posts or other vertical construction members is not recommended. In general, a post is subjected to stress along its vertical axis; and since wooden posts are purposely made very substantial, it is rare that one buckles under the stress of its load. However, if a post is spliced, a great deal of thought and care is required, since a splicing joint cannot transmit stress evenly and is liable to snap under even a small lateral force. When the lower part of a post or column has eroded and must be replaced but it is not possible to remove and replace the entire post, underpinning is often used. In Japan, the conservation and restoration of very old buildings frequently requires underpinning of old posts.

Many of the numerous joints devised for splicing posts are elaborate variations of the basic tenon joint. Further variations were devised especially for use in structures, such as five-story pagodas, requiring extremely long timbers, which were very difficult to obtain. And a large variety of splicing joints was used when flagpoles were still made of wood. Various splicing joints were used to set posts on top of high stone bases after it was determined that the lower part of a post eroded less if it rested on a stone foundation.

Still, these elaborate, complicated splicing joints cannot provide reliable strength, and few modern carpenters possess the skill to fashion them. Thus, when a modern carpenter must splice a post, he will reinforce the joint in some way with metal; but even a simple straight butt joint reinforced with metal is sometimes stronger than a complex splicing joint.

Joinery can also be used to strengthen the framework. Members joined to the framework both above and below the floor, such as sills, lintels, and fittings, help to increase the strength and stability of the basic framework of a building. Although most of the grooved lintels required for *fusuma, shōji,* and sliding windows are now chiefly ornamental, they were originally functional structural members that strengthened the framework. To further strengthen the framework and make it more rigid, all the posts are tied together with rails. One joint often used in such rails is a wedged half dovetail, either with a through pin as shown in Figure 48 or blind as shown in the drawing on page 120. When rails pass completely through the posts, as in Figure 2, wedges are driven home from both sides of the post, and the rails are sometimes further secured with a draw pin. In addition, if a mortise is cut in the bottom edge of the rail, the corresponding tenon inside the post will firmly anchor the rail.

Because horizontal bracing alone does not give sufficient rigidity to a building,

diagonal braces must also be used. If one examines wooden structures destroyed by earthquakes or the high winds that accompany typhoons, one finds that in many cases the splicing and connecting joints of the diagonal braces have snapped. I have never seen a building that collapsed because its beams and posts broke. It is therefore apparent that joints for diagonal bracing must be selected and fashioned with great care.

Connecting joints for sleepers, joists, and posts can be quite complicated, particularly when two, three, or even four members with intricate, interlocking tenons join a single post. One three-member joint, the *sampō-zashi*, is shown on page 105. Ordinarily a key or wedge is used to lock these joints firmly together, and because they can be so complex, sometimes false or inserted tenons are used instead of the genuine tenons illustrated. Because such joints as this are rather weak and snap easily, they must be reinforced with metal in order to be useful.

The Roof The *shiguchi*, or connecting joints, for the roof truss are very challenging because they must be modified according to the pitch and surface area of a given roof. The hips and valleys of roofs often require complicated joints for the hip, valley, and jack rafters. The principal rafter is simply an ascending beam that rises relative to the pitch of the roof. The connecting joints used for the principal rafter are the same as those used for diagonal braces, but here the distribution of force is quite complicated. When square purlins are joined to the principal rafter the faces are not joined flat, but instead the purlin is rotated about 45° so that one of the corners is attached to the principal rafter. Normally, cleats are used to attach the purlin to the principal rafter.

A distinctive feature of Japanese roof trusses is that purlins are invariably placed directly on top of upright posts. Characteristic trusses are the *kyōro-gumi* and *yojirō-gumi* illustrated on page 96. In constructing these trusses, after the building framework has been completed the posts and basic truss are erected first, then the purlins are set in place, and last the common rafters are added. Occasionally we can still find beautiful structures, for example, the priest's living quarters in older temples, in which all these posts have been tied together with rails, creating stunning examples of bare-rafter construction. When I see such work I can only admire the beauty of wood construction.

Because the roof, eaves, and rafter distribution are all related to the appearance and design of the façade, a large variety of connecting joints is required for different styles of construction. To properly finish the corners of a beautiful hipped or hipped-and-gabled roof is an extremely complicated operation, and it was a high honor for a carpenter to be given responsibility for marking and cutting the connecting joints for the hip rafters. Like the upper surfaces of the ridgepoles shown on page 96, the upper surfaces of the hip rafters are backed, in what is called a "sword-blade ridge." Well-fashioned joints are required where the angled hip rafters meet the ridgepole and meet and cross tie beams or wall plates; eaves supports, running parallel to the purlins, and hip jack rafters must also be joined to the hip rafters. It is not surprising, therefore, that the joints needed to connect all these members are quite complex.

Because the tie beams in the Japanese roof truss are subject to added bending stress, particular attention must be given to any splicing joint used in the beams. In practice, it is wise to reinforce with metal both splicing and connecting joints in a beam. Because metal was hard to come by, and hence expensive, when much of Japan's ancient architecture was constructed, numerous splicing and connecting joints were

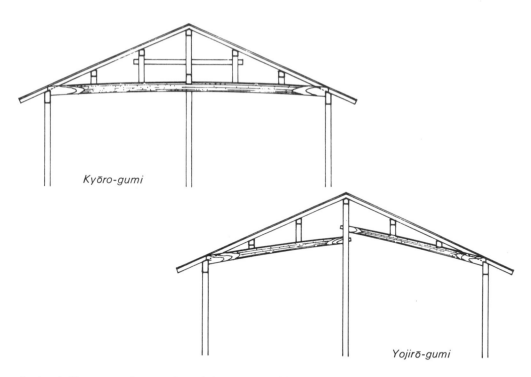

Kyōro-gumi

Yojirō-gumi

devised. But now that such articles as metal fish plates, clamps, straps, angle dogs, and bolts are readily available at reasonable prices, it is more efficient to make a metal-reinforced joint instead of a complex hand-worked, unreinforced joint.

Beams can be joined solidly to other beams or to wall plates with such devices as strap bolts. Because joists, sleepers, rails, and rafters are also kinds of beams, their splicing and connecting joints should be given the same consideration as those of the larger beams. However, since these smaller members are in general not subjected to the great strain larger beams must withstand, simple scarf joints and straight end butt joints can often be used to splice them.

Although wood has a strong natural resistance to axial stress, tension stress, and compression stress, it is not very stiff and is therefore relatively weak under bending stress. Because the strength of wood varies according to the direction of its fibers relative to the force being applied, when wood will be subjected to shearing force particular attention must be paid to the direction of the fibers relative to the force. When a timber develops checks or splits because of dryness, its shape can alter. Since checks and splits develop along the medullary rays, roughly at right angles to the annual rings or grain, in extreme cases a timber can split in two, so that what began as a 4″ × 8″ beam, for example, is transformed into two 4″ × 4″ beams. Because the two resulting small beams are much weaker than a single large beam, deflection increases and the small beams can snap.

Bracing Since wood construction consists of posts and beams, its basic form is a rectangle. Because the right angle predominates in wood construction, a carpenter can be insulted by telling him his work is not plumb or that it cants. But if you watch

the construction of a wooden building, you can see that it is no easy task to erect a plumb, level structure: a perfect rectangle is difficult to construct even if you lay it out on the ground before raising it. When erecting the framework of a structure, temporary diagonal braces are used to hold posts and beams in their correct positions during construction. Once floor and wall framing are completed, the framework is quite solid even without the temporary diagonal braces, and they are quite often removed then. However, with proper use of strong, permanent diagonal bracing, you can build a structure that will be sturdy enough to withstand earthquakes or extremely high winds. Besides diagonal braces, which run the full height of a wall from groundsill to wall plate, knee braces, horizontal braces, and so forth are used to strengthen the framework.

When constructing braces, thought must be given to the joints where the braces cross or connect with other structural members. Carpenters could display their skill in the splicing and connecting joints for purlins, ridgepoles, hip rafters, and jack rafters because these joints became very complex. In former days, when the building framework was raised, if the myriad finished joints did not fit together perfectly, the master carpenter, who was responsible for scribing the joints, was totally disgraced. Hence, even an experienced master carpenter had to devote great care to his splicing and connecting joints.

High among the many closely guarded secrets of traditional carpenters were the joints to be used where braces cross each other and where braces and rafters cross, as well as such matters as the *kiwari* techniques of distributing rafters while maintaining a natural appearance. In radial or fan-rib raftering, the façade and gable-end rafters are parallel, although, as shown in Figure 7, the rafters at the corners of the eaves are distributed like the ribs of a fan. Simply determining the distribution and joinery of these rafters is difficult enough in itself, but when you consider that the project is further complicated by the upward sweep necessary on the eaves ends of the rafters, it is easy to understand why the rules for their construction were such a well-protected secret.

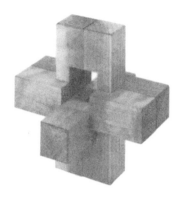

3. Tsugite: Splicing Joints

Sogi-tsugi, **the Simple Scarf Joint** In general a lap joint is most effective when joining two heavy boards or beams; however, when the pieces to be joined are light enough to be held in one hand, they can be joined effectively with a simple scarf joint. The English word "scarf" of scarf joint apparently derives from the Old Norse word *skarfr,* meaning "obliquely cut beam-end," and perhaps ultimately goes back to a suggested Indo-European word, *skerp,* meaning "to cut." The Japanese name for this joint, *sogi-tsugi,* derives from the verb *sogu,* "to slice off" or "to shave." In its plainest form, the scarf joint is simply a straight butt joint that has been sliced or shaved until its beam end has become oblique, which effectively increases the area of contact between the two members to be joined. Because it is such a simple joint to make, it has been known and used from the earliest days of carpentry.

If you glue the faces of the scarf joint, it becomes effective in resisting tension force. Increasing the area of the scarfed faces increases the area of adhesive contact, and hence increases the reliability of a glued scarf joint. However, increasing the area of the scarfed faces also reduces the effective length of the pieces being joined, greatly weakening the joint under some circumstances. Consequently, the maximum tolerable bevel for a scarf joint is probably about 30°. Although the photograph is a bit deceptive because of the camera angle, the scarf joint in Figure 10 is finished at about a 40° angle if viewed from above. If the faces met at true right angles, this joint would be a straight end butt joint, which by itself, unreinforced, should not really be called a splicing joint. A few of the more elaborate variations of the simple scarf joint devised over the centuries include the *okkake-daisen-tsugi* (Fig. 23), *kanawa-tsugi* (Fig. 24), *isuka-tsugi* (Fig. 25), and *miyajima-tsugi* (Fig. 26).

In Japan, the simple scarf joint has long been used to splice rafters that will not be visible when construction is completed. In the days when nails were rare and precious, the scarf joint, requiring only one or two nails to reinforce it, was widely favored in construction. Now that nails are cheap and readily available, carpenters are free to use other types of joints and need not rely so heavily on the simple scarf joint; but even so, it is still the joint used for splicing rafters.

Neither the simple scarf joint nor the plain lap joint actually joins or unites its mem-

bers until they are bolted, nailed, strapped, or glued together. Without such reinforcement, these joints are simply ways of aligning timbers and cannot transmit force effectively. Japanese carpenters devoted a great deal of thought and energy to devising complex joints to splice boards and beams without relying on metal or glue to reinforce the joints. But even in such ancient structures as at Hōryū-ji, where we find these complex joints, we can be sure that the majority of them were fashioned in relatively recent times, following the improvements made in tools during the Edo period.

Koshikake-tsugi, the Lap Joint Just as electrical plugs are classed as male or female, the two members of a joint can be classed as male or female. Ordinarily, whether a joint is male or female is determined by its shape, but with some joints, for example, the lap joint shown in Figure 11 or the end lap joint shown in Figure 35, the two members are identical and it is difficult to tell which should be the male joint and which the female.

Koshikake literally means "seat," "bench," or "chair," and in general when joining beams, the face of the female joint forms the supporting base, or seat, on which the male joint rests. In principle, the male joint covers, overlaps, or fits into the female joint. Following this principle, in the case of a simple lap joint, where both members are the same shape, the member put in place last is called the male joint. Sometimes the female joint is also called the seat or chair (*koshikake*).

Although intricate joints requiring delicate cutting may be very useful for such fixtures as *shōji* or for fine cabinetmaking, they are not suitable for heavy construction. The lap joint, however, with its plainly cut faces, which give it a much greater holding area than that of the simple scarf joint, is admirably suited to heavy construction. Although the lap joint is simple enough that it can be cut quickly on the construction site, it be cut well ahead of time without great danger of warping. It is still necessary, however, to reinforce this joint with metal or glue.

Ari-tsugi, the Dovetail Joint The *ari-tsugi,* or dovetail joint, is the simplest self-locking joint, but it is not very efficient at doing anything else. The English name of this joint is derived from the shape of its pin, or tapered tenon, which resembles the fanlike tail of a dove. In the common dovetail joint, the pin is the male half and the socket, or tapered mortise, is the female half. By combining the common dovetail and the lap joint, Japanese carpenters created the *koshikake-ari-tsugi,* or dovetailed lap joint, shown at right and in Figure 12. Here the pin, or male half, of the common dovetail is added to the male half of the plain lap joint. The dovetailed lap joint integrates the self-locking feature of the common dovetail and the strength of the lap joint and is commonly used in Japan as a splicing joint in groundsills.

Although the pin resists shear and flexion, both the pin and the socket will split along the grain if angled too acutely; hence, this joint and its variations are not particularly useful in framework construction. The dovetail joint is generally used where strength is not a major consideration. Its many variant forms in Japan include the *ari-otoshi,* shown in Figure 49, and various types of *ari-kake,* such as those shown in Figures 50–52.

Because the shape of the dovetail joint is interesting and rather pleasant, it has long been favored in both Japan and the West as a functional but decorative joint on articles where it will be seen. The dovetail is widely used in cabinetmaking, though most

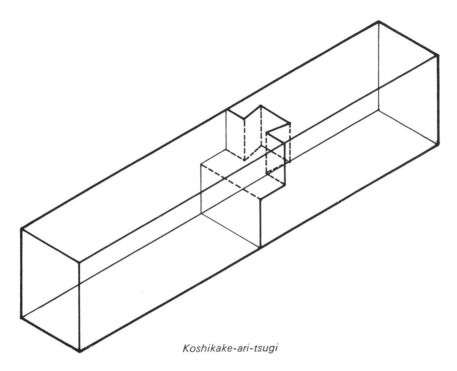

Koshikake-ari-tsugi

of us may notice it only as the joint always used to finish drawers. In Japan it is also used to finish all manner of containers, from the tiniest of boxes to the huge open chests that hold copper braziers used for cooking or heating a room. Although the basic shape of the dovetail is quite simple, it lends itself to many variations.

One variation often used in Japan to tie planks together is the dovetail feather joint, which looks like two dovetail pins set point to point. In a popular version, the ends of the dovetail feather, or key, are rounded so that the feather has almost an hourglass shape. Both these shapes are used to join heavy wide boards together to make such things as table tops, and since the shape of the dovetail feather is pretty in itself, no one seems to mind much that it shows in the finished table top. Far from it. The joint not only offers the opportunity for a carpenter to demonstrate his skill but also can be quite decorative, and so we often find that the wood for the feather has been selected not only for strength but also for its texture and color contrast with the wood of the table surface.

***Mechigai-tsugi,* the Stub Mortise and Tenon** A stub tenon, or *mechigai,* is used simply to strengthen a splicing joint and does not legitimately constitute a method of joining two pieces of wood. According to the effort and care put into their construction, the range of stub tenon joints is very wide, from the very simple to the extremely complicated. In the case of a dovetail joint, if it has no holding surface other than its pin and socket, the spiral grain twist between the male and female halves of the joint will concentrate in the base of the pin; but if additional holding surfaces are worked into a joint, the spiral grain twist will be transmitted through them, as well, strengthening the dovetail joint. In stub mortise and tenon joints, such as those shown in Figures 13–16,

the tenon is part of the male half of the joint. The increased contact surface of a stub mortise and tenon joint increases the firmness of the connection of its two members.

Sometimes a joint will appear to be a plain butt joint; however, if you take it apart, hidden inside you may find a U-shaped tenon, as in the *hako-mechigai-tsugi* (Fig. 34), or an L-shaped tenon, a variation of the *kaneori-mechigai-tsugi* (Fig. 28). Traditional carpenters displayed their skills in creating such complex blind mortise and tenon joints as these.

In making some articles, such as picture frames, drawers, fine cabinets, or even *shōji* and *fusuma*, very often we do not want to use nails, which would show and detract from the appearance of the finished article. For such work, mortise and tenon joints are ideal, since they can be quite strong when glued and need not be reinforced with nails. Now that synthetic adhesives stronger than wood itself are available, excellent results can be achieved by gluing together very complicated mortise and tenon joints with extensive holding surfaces.

Unless it is glued, a mortise and tenon joint is not effective in resisting tension force. Without gluing, it can transmit only such forces as spiral grain twist. With or without glue, however, mortise and tenon create a strong joint, and the type of mortise and tenon selected will affect the strength and durability of the joint.

Hagi-tsugi, Board Jointing So far we have discussed some basic joints for splicing boards or beams end to end, but there are also many ways to join boards side by side, parallel to the grain. The basic board joints, illustrated in cross section at right, are the straight, scarf, V groove or bird's mouth, shiplap, tongue and groove, and feathered or splined joints; these are all simply variations of joints we have already discussed.

Choosing and fashioning joints to connect boards for paneling, flooring, or where the work will be given a particularly fine finish, such as table tops or *tokonoma* floors, has long been time-consuming for the carpenter. Now that excellent adhesives are available, it is technically feasible to use the straight joint for all such work; however, it frequently happens that the synthetic resins and high-polymer adhesives used, which are so much stronger than wood, do not yield with the natural expansion and contraction of the wood. This puts such a great strain on the wood in a glued joint that it will often split and break beside the glued surface. In most cases, the only way to avoid this is to use a judicious combination of the traditional joints and the new adhesive agents.

The straight joint, which is simply a kind of butt joint, has many uses, such as for interior paneling or flooring; but it is probably used most by cabinetmakers because it is a good joint for short, lightweight pieces where great strength is not required. This is the joint normally used for drawer bottoms, for example. The scarf and V groove or bird's mouth joints can be used almost anywhere that you would use the straight joint, but because of their beveled edges they have a greater tendency to split, so would not be very good choices for work subjected to much stress, such as floors.

As its English name implies, the shiplap joint, which is a variation of the common lap joint, probably originated in the West among shipwrights. This joint is especially good for paneling and can be used for exterior siding. It can be made virtually waterproof by putting battens over the finished seams or, where appearance is a factor, by putting battens over the seams on the underside of the work. The tongue and groove

Straight Joint

Scarf Joint

V-Groove or Bird's Mouth Joint

Shiplap Joint

Tongue and Groove Joint

Splined Joint

joint, which can be considered a variation of the mortise and tenon, is used mostly for hardwood flooring, although it is equally satisfactory for paneling. Because the tongue is cut along the grain and is an integral part of the board, the joint is easily split if it is made in soft wood. This problem may have contributed to the development of the feathered or splined joint, which in the West is considered a variation of the straight joint but in Japan is considered a variation of the tongue and groove using a "false" or inserted tongue. When this joint is used with soft woods, the spline, or inserted tongue, is cut from hardwood. Cabinetmakers vary the joint even more, cutting their splines across the grain for added strength. Although this joint was once widely used for flooring, it has been generally replaced by the tongue and groove and is now used mostly by cabinetmakers.

All these joints can be reinforced with dovetail feathers or, where appearance is not important, with corrugated fasteners. But with the strong adhesive agents available now it is no longer necessary to reinforce them and the beautiful dovetail or hour-glass-shaped feathers are now used primarily not to strengthen a joint but as decorative elements.

Kama-tsugi, **the Gooseneck Mortise and Tenon** The *kama-tsugi,* or gooseneck mortise and tenon, got its Japanese name from the male joint's resemblance to the reared head of a snake: *kama kubi,* the extended form of *kama,* means both gooseneck and the reared head of a snake. The gooseneck mortise and tenon is one of the joints devised specially to resist tension force, and the male joint was greatly refined over the years. In ancient structures the neck of the male joint is generally square and the joint itself is rather roughly finished. But in later structures, with improvements in tools

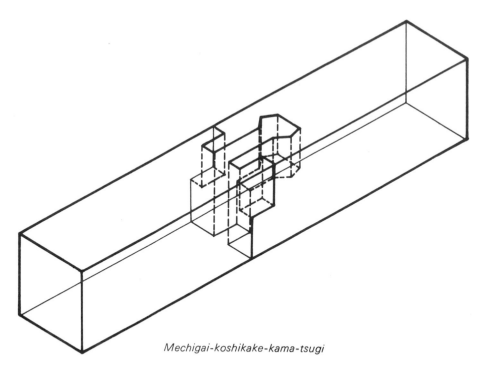

Mechigai-koshikake-kama-tsugi

and techniques, the joint becomes both more accurate and more complex, like the variation in the isometric projection above.

Carpenters generally refer to the gooseneck mortise and tenon by the length of its neck: four-*sun kama*, five-*sun kama*, six-*sun kama*, and so forth. The *sun* is a traditional Japanese measurement equal to roughly 3.03 cm., or 1.19 inches; thus, the commonly used five-*sun* and six-*sun kama* have necks about 15.2 cm. and 18.2 cm. long. Although it might seem that with a longer neck the joint would be better able to resist tension stress, the length of the neck does not really affect the strength of the joint much. Therefore, for groundsills a four-*sun kama*, with a neck about 12.1 cm. long, is quite adequate.

If you wish to make a very long-necked joint, it is necessary to begin with correspondingly longer beams to allow for the overlap in the male joint. In order to avoid reducing the effective length of the timbers when it is not possible to start with longer beams, an inserted neck will sometimes be used. In this case the mortise, or female end, of the gooseneck tenon is duplicated in the male half of the joint, but all other parts of a complex joint are made as usual. A separate tenon, similar to the one shown in Figure 20, is then made, with the neck and head of the male joint duplicated on either end, and this is driven into the double female joint. If the inserted neck is made of some hardwood, like oak, the joint's resistance to shearing stress is increased; so with the inserted neck you can not only preserve the effective length of the lumber but also increase the tensile strength of the joint.

Although the principle of the *koshikake*, or lap joint, is to lap half a board or beam over half another board or beam, this joint can be combined very effectively with the gooseneck mortise and tenon to produce the strong and useful *koshikake-kama-tsugi*,

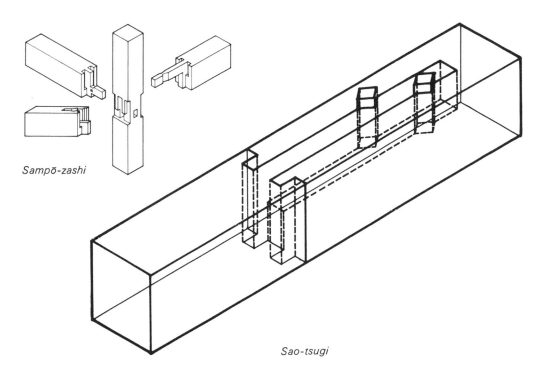

Sampō-zashi

Sao-tsugi

shown in Figure 17. If you combine a *mechigai*, or stub mortise and tenon, with a gooseneck and a lap, you can create the *mechigai-koshikake-kama-tsugi* in the projection at left and shown in Figure 18. This joint is particularly effective in resisting the strain often placed on a joint as its members dry out and shrink apart.

***Sao-tsugi*, the Lapped Rod Mortise and Tenon** The gooseneck mortise and tenon employs an unusually shaped tenon to join its members firmly. Sometimes, however, it is necessary to firmly connect beams in places where it is impossible to use such intricately shaped joints, which can be put together only by dropping the male joint into the female joint from above. In such cases, the *sao-tsugi*, or lapped rod tenon, projected above and shown in Figure 19, is particularly useful. This joint is quite often used for large beams in Japanese residential construction.

In Japanese wood construction it often happens that a lintel, large beam, or similar horizontal member must pass completely through one of the solid, unspliced main structural posts running from groundsill to wall plate or ridgepole. In order to join these horizontal members without weakening the post, a very long rodlike half or lap tenon is driven through the post, into a female joint on the other side of the post. As shown in the drawing of the *sampō-zashi* above, stub tenons are used to anchor the horizontal pieces to the post itself. Once the male and female halves of the lapped rod tenon are in place, two keys are driven into the joint, on either side of the tenon, to firmly lock it. Normally a hardwood key is used, but occasionally metal keys are used, in which case the joint is further tightened with a through bolt.

Usually when a horizontal member, such as a lintel or beam, joins a post, a tenon is cut in the end of the beam and fitted into a mortise cut in the post. When it is not

possible to use this kind of jointing, as when the beam is not long enough to allow cutting of a tenon, an inserted tenon is used. Shouldered dovetailing is used to join the inserted tenon and the post, and a mortise is cut in the beam. When connected, this joint is reinforced with a key. One method of joining two beams to opposite sides of a post is to mortise the ends of the two beams, cut shallow mortises on either side of the post to accept the beams, and cut a small mortise through the post. An inserted tenon is then run through the mortise in the post and connected with the mortised ends of the two horizontal members on either side. This technique is used to attach the decorative beam-end nosing so widely used in temple architecture.

Daimochi-tsugi, the Oblique Scarf Joint with Stub Tenon The *daimochi-tsugi,* an oblique scarf joint with stub tenons, is usually used to join beams in the Japanese roof truss. In using this joint, the female half, which resembles a rest or platform on which the beam with the male half will be placed, is supported by the top of a post or girder and extends about 30 cm. beyond the edge of the post or girder. Because it is very difficult to fashion true and reliable joints at the ends of the whole, barked logs so often used as cross beams in Japan, the *daimochi-tsugi* is an excellent joint for connecting such beams, since the male joint, cut on both ends of its beam, rests on and is supported by the projecting female joint.

To make this joint even more secure and to prevent shifting, in addition to the stub tenons hardwood pegs are used inside the joint, as shown in Figure 22. When the joint is in use these pegs are vertical, not horizontal as shown. The pitch of the angled face of the *daimochi-tsugi* should be about 1/25 the apparent depth of the beam, as shown in Figures 21 and 22, and the ends of the scarf are not plain but have single stub tenons.

Because the *daimochi-tsugi* is so often used to splice sleepers, joists, wall plates, and tie beams in the middle, it is also called the "center joint." When splicing logs of different diameters, it is necessary to shape the logs to ensure a secure joint, and when spliced, one log appears to project from the other and the joint itself does not show. In these cases, the female half of the joint is hollowed out of the upper face of the larger log. Because this shaping makes the log resemble the mouth of a small sakè bottle, this *daimochi-tsugi* is also called the "sakè bottle joint." When the smaller male half of the joint is firmly cradled in the female half, with the reinforcement from the internal pegs and the stub tenons, this is a good secure joint that will not shift. Because the logs spliced with this joint are rarely of the same diameter, the real challenge in fashioning it is shaping the logs where the joint faces are to be cut.

Okkake-daisen-tsugi, the Rabbeted Oblique Scarf Joint Because the *okkake-daisen-tsugi,* or rabbeted oblique scarf joint, resists tension and bending stress, it has many uses, such as in splicing beams or lintels or in underpinning. Since the male and female halves of this joint are cut identically, even down to the tapered keyholes, the half driven home is considered the male half. Usually the face in the center where the joints lap is cut at an angle, as shown in the drawing at right. When cut this way, of course, the male half can be driven home from only one side, but it is a bit easier to get a tight joint. Sometimes, however, the center lap is cut at a right angle to the edge of the work, as shown in Figure 23, and then the joint is also known as a *wari-tsugi,* or divided joint.

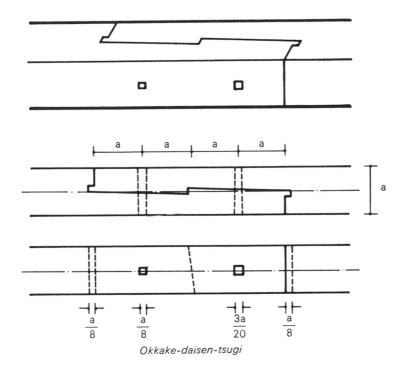

Okkake-daisen-tsugi

The *okkake-daisen-tsugi*, *okkake-tsugi* (a variation that does not use keys), and *kanawa-tsugi* all belong to the same general class of joints and are really not very different from each other. They were devised and greatly refined as carpenters' skills increased with the development of new tools and techniques in the last few hundred years; however, these joints are not particularly strong. For example, tests conducted on a 9 cm. square beam (about 3 1/2'' × 3 1/2'') spliced with an *okkake-daisen-tsugi* revealed that its tensile strength was only one-tenth that of a sound 9 cm. square beam of the same wood. In general, then, it would seem that this joint should be used in framework only where it will not be subjected to great tension stress. However, it is sometimes used for the underpinning of pillars being restored in ancient Japanese architecture.

In a horizontal member, whether the joint is made so that the keys enter from the side or from the top depends on the type of stress the joint will have to withstand. For example, if the joint will be subjected to bending stress, then the key side should be uppermost so that the rabbeted ends of the joint can be brought into full play to resist both bending and compression force. However, when this joint is reinforced with bolts, straps, or plates, it seems to work equally well in either position.

Kanawa-tsugi, the Mortised Rabbeted Oblique Scarf Joint Because the *kanawa-tsugi*, or mortised rabbeted oblique scarf joint, has stub tenons cut in its rabbeted ends, without some adjustment you cannot simply slide the two pieces together from the side, as you can with the *okkake-daisen-tsugi*. Hence, the total length of the internal faces is reduced by the length of the stub tenon, taking half the length off each face, as shown in the isometric projection overleaf and in Figure 24. When the key is driven

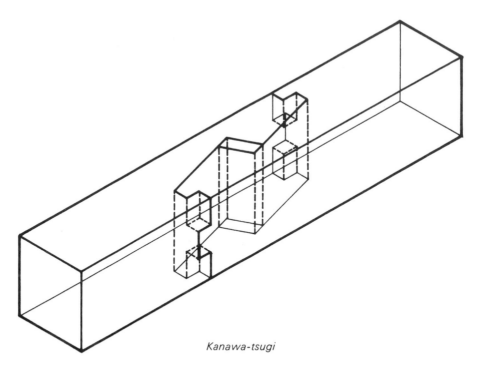

Kanawa-tsugi

home, this space is taken up and if the joint is accurately cut it becomes rigid and strong. The *okkake-daisen-tsugi,* the *kanawa-tsugi,* and its chief variant, the *shiribasami-tsugi,* were all devised to resist tension and bending stress; in all three of these joints the male and female halves are identical.

The *shiribasami-tsugi* differs from the *kanawa-tsugi* only in the placement of its stub tenons. With the *kanawa-tsugi* the mortise and tenon are cut on the outer surfaces of the rabbeted ends, where they are visible; but with the *shiribasami-tsugi* the placement is reversed, so that the tenons are cut on the inner faces of the rabbeted ends that are mortised in the *kanawa-tsugi.* This reversal, of course, means that the depth of the rabbet must be increased to accommodate the blind tenon.

Like the *okkake-daisen-tsugi,* the *kanawa-tsugi* and the *shiribasami-tsugi* are used for the underpinning of pillars. They are particularly favored because the key, which is driven home last, acts as a substitute jack and creates a firm joint. Both these joints are relatively easy to make and appear to be structurally sound. When they are reinforced, even with only a bolt and strap, they become almost as strong as a sound beam or post of the same dimensions.

Only after the development of improved tools, and the attendant advances in carpentry techniques, was it possible to fashion blind tenons. Because fashioning the *kanawa-tsugi* and *shiribasami-tsugi* requires such advanced tools and techniques, we can be certain that these joints were devised and refined by carpenters of the Edo period.

***Isuka-tsugi,* the Halved Rabbeted Oblique Scarf Joint** The Japanese name of the crossbill finch is *isuka,* and the halved rabbeted oblique scarf joint shown at right and

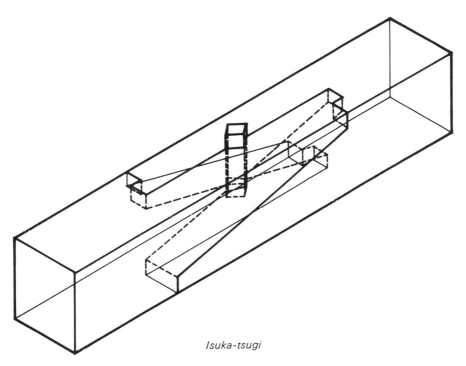

Isuka-tsugi

in Figure 25 is known in Japanese as the *isuka-tsugi*, or crossbill joint, because of its resemblance to the overlapping crossed beak of the crossbill finch. Since the male and female halves of this joint cross each other, one could think of it as a crisscross scarf joint. The strain on the joint is offset and the finished joint is inconspicuous because the male and female halves of the joint cross. Perhaps for this reason the *isuka-tsugi* is widely used in splicing the exposed battens and coping used in Japanese-style coffered ceilings.

The *miyajima-tsugi*, a halved oblique scarf joint (Fig. 26), is a variation of the *isuka-tsugi* and was also devised as an inconspicuous splicing joint. The *miyajima-tsugi* takes its name from the island Miyajima, where this joint is used in the famous great torii of Itsukushima Shrine. The *miyajima-tsugi*, with the faces of its crossing pieces also cut obliquely, appears to be a complicated joint; but it is virtually useless structurally. It must be included among what are known in Japanese as "cosmetic joints," which are more decorative than functional. The *ken-isuka-tsugi*, a bird's mouth joint (Fig. 27), was devised to eliminate the unsightliness of the interlocking faces of the *isuka-tsugi* and is also a cosmetic joint.

Before construction can begin on a building, the boundaries of its foundation and outside walls must be laid out by erecting batter boards at the future corners of the structure and attaching to them reference lines to define excavation boundaries, walls, foundation level, and so forth. Although batter boards, which are rather flimsy, are only temporary fixtures, it is imperative that they not be dislodged or in any way disturbed before the reference lines are no longer needed. Because people will not be tempted to sit or to put something on the top of a post or stake finished *isuka* style (so that it resembles the *miyajima-tsugi* without a key), in Japan the tops of the stakes to

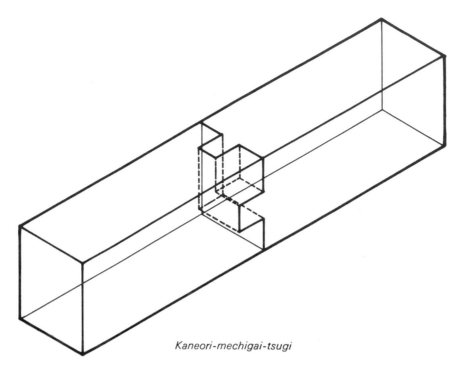

Kaneori-mechigai-tsugi

which the batter boards are attached are cut in this style. It does indeed discourage people from disturbing the batter boards. Although the *isuka*-style cut looks fairly complicated, basically it is made by ripping a board along the grain and it is actually rather easy to fashion.

***Kakushi-mechigai-tsugi*, the Half Blind Stub Tenon** As shown in Figures 29 and 33, the *kakushi-mechigai-tsugi* is a half blind stub tenon joint in which the mortise and tenon are visible from only one side of the work. Although the tenons of *kakushi-mechigai-tsugi* are centered in the pieces to be joined, in one variation, the *kaneori-mechigai-tsugi* (the half blind L-shaped stub tenon, shown above and in Figure 28), the mortise and tenon are visible on two faces. These joints, employed where great exactness is required, were so frequently used for the tops of *inrō*—the once commonly used medicine cases so popular with collectors these days—that they are also known as *inrō-tsugi*.

Among splicing joints related to the *kakushi-mechigai-tsugi* are the *jūji-mechigai-tsugi*, or cross-shaped stub tenon (Fig. 30); the *kakuhozo-imo-tsugi*, or blind square stub tenon (Fig. 31), and the *ōgihozo-imo-tsugi*, or blind fan-shaped stub tenon (Fig. 32), both thought of in Japan as straight joints reinforced with a stub tenon; and the *hako-mechigai-tsugi*, or blind U-shaped stub tenon (Fig. 34). In the West the *jūji-mechigai-tsugi* is known as a multiple-tenon joint, considering the projections on the member in the left-hand side of the photo to be four individual tenons; but in Japan this joint takes its name from the shape of the projection on the member shown in the right-hand side of the photo.

In Japan these joints are frequently used for fixtures like decorative beams and the

grooved lintels for *fusuma* and *shōji*, and for such fittings as *fusuma* and *shōji*. The final choice of joints takes into consideration not only finished appearance (when, for example, you need the strength of a stub tenon in a joint that must look like a straight butt) but also spiral grain twist and the direction of the forces the joint will be expected to transmit.

When fashioning these joints, if the tenon or male half of the joint is cut first, it can be used as a template for scoring the female half of the joint. It should be remembered that the tenons of the blind joints must be pointed, that is, their edges must be beveled, in order to keep them from splintering when they are driven into the mortise. Although carpenters reinforce many joints with the strong adhesive agents now available, there is little point in gluing any of these joints because none of them is very reliable structurally. When a strong splicing joint is required, these joints should not be used.

When wood dries out not only does it shrink, opening up what might once have been a tight joint, but it warps. Warping is particularly common at joints, where the natural reactions of the wood fibers are less restricted or controlled. Beautifully crafted joints that once had perfectly flush faces can become so warped that they present only an unsightly jumble of odd, ragged edges. The *kakushi-mechigai-tsugi* was devised to control the distortion caused by warping, and the blind variations of this joint were devised to control the distortion without being obvious.

4. Shiguchi: Connecting Joints

Ai-jakuri, **the End Lap Joint** If you include the straight end butt joint among splicing and connecting joints, then it must be considered the simplest of all joints, followed by the plain scarf joint. After these two in simplicity come the halving joints, including the *koshikake-tsugi,* or lap joint, discussed earlier and the *ai-jakuri,* or common end lap joint, shown in Figure 35. In Japan the term *ai-jakuri* refers to both shiplap and halving joints.

Because the construction of halving joints is so simple, we can probably quite safely say that these are the earliest true splicing and connecting joints. Certainly their frequent appearance in the late-seventh-century structures at Hōryū-ji is not surprising and lends credence to arguments for their antiquity. But these joints are not firm and will shift and separate without a key, wedge, or tenon to lock them.

Halving joints are still commonly used for groundsill construction. When an end lap joint, like the one shown in Figure 35, used at the corner of a groundsill is mortised to accept a tenoned corner post, you can create a strong joint. This type of corner joint is generally used in construction in both Japan and the West because it is effective and reliable, yet still simple to construct. However, when using this connecting joint at the corner of a groundsill, since the two sill timbers have been first weakened by being halved and then further weakened by being mortised, it is wise to reinforce the joint with metal and to brace the post.

Halving joints are useful not only for lengthwise splicing and L-shaped connecting joints, but also for T- and cross-shaped connections. As simple as it is, a halving joint is particularly strong and useful where cross-shaped joins are involved. But since half a beam is considerably weaker than a whole beam, instead of using a cross lap joint (Fig. 55) a carpenter might choose the stronger cogged lap joint (Fig. 56).

When selecting a splicing or connecting joint, you should take into consideration not only the special characteristics of the joint but also the position it will occupy in the total framework and how that position and the joint's special characteristics will affect and be affected by each other. You should keep in mind that there are often times when a reinforced straight end butt will be perfectly adequate and an intricately cut joint just is not necessary.

Wanagi-komi, **the Open Slot Mortise with Whole-Timber Tenon** When joining two timbers of very different dimensions, inevitably the smaller timber will be subjected to greater stress and will snap quite easily. When it is necessary to join two such unequal members, one wants a joint that enables the smaller timber to carry its full share of the load but does not weaken the smaller timber. The Japanese carpenter's solution is the *wanagi-komi* (Fig. 37), an open slot mortise in which the whole smaller timber becomes the tenon. This joint is frequently used at the tops of posts where tie rails must join the posts. By cutting an open mortise in the top of a post, the whole tie rail can be joined to the post. If a through mortise is cut in the post, in order to ensure a firm joint it is generally necessary to use one of the splicing joints discussed earlier to connect the rail to the post, which of course weakens the rail. When the *wanagi-komi* is used, the smaller timber is especially resistant to spiral grain twist. Under such stress, in fact, the mortised post generally splits and breaks, while only rarely does the smaller timber break because of spiral grain twist.

When timbers of dimensions larger than those shown in Figure 37 are used, a tenon, called the *wanagi* tenon, is cut in the center of the mortise in the post. A corresponding mortise cut in the bottom edge of the smaller timber ensures a firm joint once the timber is seated. The *wanagi* tenon is normally used with the ridgepole and king post in the Japanese roof truss. Although the king post is subjected primarily to compression stress, it must be as substantial as a beam that is subjected to bending stress because so much of it is cut away in fashioning various joints. At the top of the king post, where the ridgepole and principal rafters join it from three directions, the structural *shiguchi,* or connecting joints, become especially complicated, affording a master carpenter the opportunity to demonstrate his skill.

The *wanagi-komi* is used as a connecting joint wherever unequal timbers come together in a T shape, as ridgepole and king post, or posts and tie rails. Where members of the same dimensions come together in an L shape, such as at the corners of sills, Japanese carpenters use a variant of the *wanagi-komi* known as the *sammai-gumi,* literally, "three-leaf set." Known in the West as the open slot mortise, the *sammai-gumi* (Fig. 36) gets its Japanese name by counting the sides of the mortise as two leaves and the tenon as the third leaf of the "set." This joint, mortised to accept a tenoned post, is often seen in the West at the corners of solid groundsill construction.

When timbers of the same dimensions are joined with a slot mortise, it is necessary to cut a square-shouldered through tenon in one of the members, and this particular style of tenon is known as the *sammai-hozo,* or "three-leaf tenon," after the *sammai-gumi* joint. If the joint being made is the common dovetail, which is basically a variant of the open slot mortise, then the pin (which is simply a tapered tenon) is known as the "dovetail three-leaf tenon" (*ari-gata-sammai-hozo*). Because they are so useful and often used, a great number of variations of the *wanagi-komi* and *sammai-gumi* have developed over the centuries.

Ō-dome, **the Mitered Open Mortise** The *ō-dome,* or mitered open mortise (Fig. 40), and the *hako-dome,* or rabbeted tenoned miter joint (Fig. 41), are useful as corner joints for architraves, cornices, coping, baseboards, door and window frames, and so forth. These joints are not particularly strong structurally, but when carefully made they give a very nice appearance to the finished work. Although *tome,* or *dome,* means

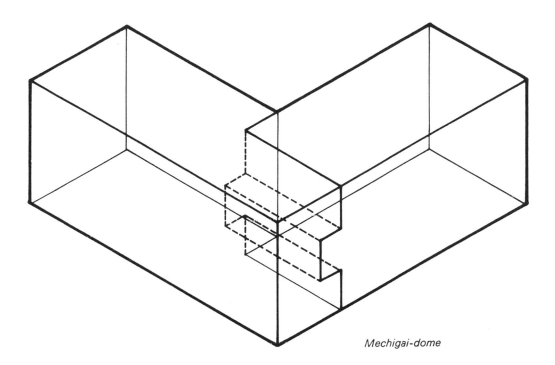

Mechigai-dome

"miter joint," these joints are grouped with the *mechigai-dome,* or rabbeted stub tenon (shown above and in Figure 38), and the *ari-dome,* or housed dovetail (Fig. 39), so we could more properly consider all these joints as belonging to a class of corner finishing joints. The purpose of each of these joints is to create a firm joint while concealing the actual structure of the joint. For this reason, they are useful not only in interior construction but also in cabinetmaking and furniture making.

One major problem with corner finishing joints, however, is that if not carefully made they tend to open after a time, largely because wood shrinks as it dries out with age. One way to avoid this problem is to use only very well seasoned wood in miter joints. In the past, carpenters also paid a great deal of attention to the grain in the wood and before cutting a joint would turn the pieces or alter the angle of the miter to compensate for the effects of future shrinkage. Then the carpenter would consider the placement and shape of his mortise and tenon and the effect they would have on the joint, and only then would he mark and cut his joint, to create a firm joint that took advantage of the character of his lumber and would in time shrink tightly together rather than apart.

Mortising a miter joint not only strengthens it but also helps control the effects of shrinkage. A tenon that is fan shaped in cross section, like the one in Figure 32, is more effective than a square tenon in controlling shrinkage and warping, and two or more small tenons are more effective than a single large one. To keep miter and finishing joints from opening up, Japanese carpenters favored the use of a variety of shaped joint faces ranging from the *hako-dome* (shown overleaf and in Figure 41) to much more complex joints like the *daiwa-dome* shown overleaf. With the recent development of extremely strong synthetic adhesives, however, glued miter or finishing joints only

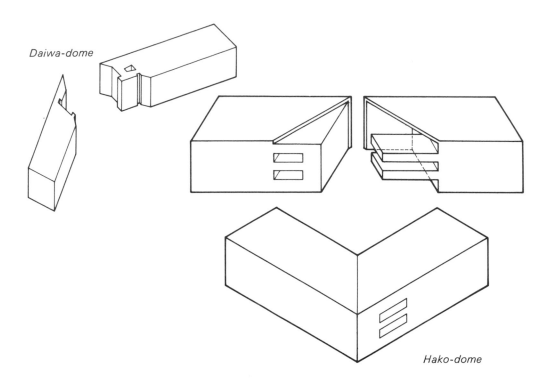

Daiwa-dome

Hako-dome

rarely open up. With careful cutting and a good adhesive, the modern carpenter can achieve excellent results with the simple joints and need not invest the great time and energy carpenters formerly put into selecting, marking, and cutting a finishing joint.

Hira-hozo, the True Mortise and Tenon The main differences between the *hira-hozo*, or true mortise and tenon, and the *mechigai-tsugi*, or stub mortise and tenon, are the longer tenon of the *hira-hozo* and the square shoulders cut on all four sides of the *hira-hozo* tenon, as shown at right. This joint is used at either end of a post to connect it firmly to the groundsill, wall plate, or other beams. In addition, if the post is mortised this joint can be used to join nonbearing beams to the post.

When the *hira-hozo* tenon is a through tenon, as at a groundsill corner, it is called a *naga-hozo*, or long tenon. Normally this joint is used primarily to control shifting, so a shorter tenon, about two-thirds the depth of the mortised member, is used, as shown in Figure 42. Where partition and pole plates cross, a tenon must pass through both of them and hence needs to be much longer than usual. In such cases, to avoid the great weakness inherent in an extremely long tenon, the tenon must be modified. One very satisfactory solution is the *kone-hozo*, or rabbeted mortise and tenon, shown at right and in Figure 43.

The numerous variations of the *hira-hozo* used in Japan all begin with a substantial base at the body of the tenon. The body of the tenon may then be rabbeted, as in the *kone-hozo*, or perhaps cut as a double tenon above the base, or even as a multiple tenon, like the *jūji-mechigai-tsugi* (Fig. 30). Usually the *hira-hozo* tenon is an elongated rectangle in cross section, but this tenon is also seen cut square, fan shaped,

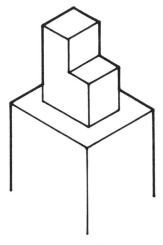

Kone-hozo Tenon

and even circular. In addition to these more basic shapes, there are many more complicated forms, including rabbeted multiple tenons.

In making mortise and tenon joints, one must remember that cutting away good wood to shape a tenon reduces the bearing surface of a beam, greatly weakening it. Therefore, instead of relying always on true tenon jointing, we should also consider joints like the *wanagi-komi*, where a whole timber becomes the tenon to be seated in a mortise. It may seem paradoxical, but everything we do in the way of shaping tenons and mortises to increase the strength of a connecting joint involves reducing the cross-sectional areas of the members of the joint, resulting in a joint that must be weak under certain stresses.

Hana-sen, the External Draw Pin Joint Draw boring is an excellent technique for creating a good, firm joint. The holes for the pins are offset slightly so that when the pins are driven in they draw the tenon shoulders tightly against the mortised timber; but there is the danger that if carelessly made this kind of joint can put so much strain on the mortise and tenon that they split.

An external draw pin can be used when a through tenon extends well beyond the mortise, as shown in Figure 44. The projecting part of the tenon, or tongue as it is sometimes called in the West, is known in Japan as the *hana*, or nose, giving this joint its name: *hana-sen*, literally, "nose pin." When it is not possible to use the *hana-sen*, or external draw pin, for example, if the tenoned timber is not long enough for an extended tongue or if there is not enough working room, there are still several other ways to lock joints. You can use a draw pin through the mortised timber, the *komi-sen* shown in

Figure 45, or various kinds of wedges, such as those shown in Figures 46 and 47.

The *hana-sen* takes its name directly from the location of its pin, but *komi-sen* is a more general term for the type of draw pin joint shown in Figure 45. In Japan there are many variations of this joint, each with a special name that indicates the location of the pin—whether it is in the center of the post, closer to one edge or the other, and so forth.

The joints locked by the *komi-sen* method generally carry quite heavy loads, since it is usually used where girders, for example, join posts. Because such loads would be too heavy for the tenon alone to carry, an *ōire*, or beveled shoulder mortise and tenon joint (Fig. 53), is ordinarily used for these joints. As happens more often these days, it is not always possible to get timbers long enough to make proper mortise and tenon joints that can be draw bored and pinned with a *hana-sen* or even a *komi-sen*. In these cases, carpenters must rely on inserted tenons, similar to the one in Figure 20, which are then pinned at both ends. Draw boring and pinning with a *komi-sen* is still the most commonly accepted method of reinforcing T-shaped joints, but in recent years bolts have replaced the wooden pins originally used.

Wari-kusabi, the Split Wedge Joint *Wari-kusabi*, or split wedges, seen in Figure 46, are often used in the end of a through tenon as a means of locking it in place. The two sides of the mortise that are parallel to the wedges are tapered slightly so that the opening next to the tenon shoulder is narrower than the opening where the wedges will be driven in. When the wedges are driven in, they split the tenon, spreading it and wedging it securely into the mortise.

Most of us are familiar with this joint, since it is commonly used to attach hammer and ax heads to their handles. You may have noticed that in the head of a hammer a metal wedge is often used instead of a wooden one. This is because wood shrinks as it dries out and old wooden wedges have a great tendency to slip out; they should therefore be glued to prevent this. However, the problem does not arise with the wedged blind tenon.

The wedged blind tenon, shown in one variation at right and in another in Figure 47, is known in Japanese as the *jigoku-kusabi*, literally, "hell wedge," possibly because once this joint is put together there is no way to take it apart, just as there is supposed to be no escape from hell for anyone once there. Because this is such a strong, permanent joint and the wedges do not show in the finished work, it is often used where appearance is important and is greatly favored by cabinetmakers and furniture makers. In Japan it is regularly used to attach legs to tables.

In making this joint it is especially important to begin with very well seasoned wood so there will be little or no shrinkage, because once this joint is finished it is impossible to adjust later for excessive shrinkage. With fairly substantial timbers, the tenon will be about 5 mm., or 3/16", shorter than the depth of the mortise. Wedges about two-thirds the length of the tenon are driven into the end of the tenon before it is started into the mortise. Because it is most important that the end of the tenon not spread before it is in the mortise, small slots are cut into the end of the tenon to support the wedges initially.

As with any other split wedge joint, the sides of the mortise parallel to the wedges must be tapered, rather like a dovetail socket, so that the mortise is the same shape the

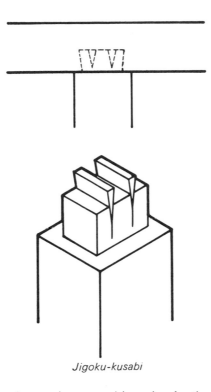

Jigoku-kusabi

tenon will assume when the wedges are driven in. As the tenon is driven into the mortise, the wedges are forced into the end of the tenon, spreading it so that it resembles a dovetail pin and permanently locking it inside the mortise. The *jigoku-kusabi,* or wedged blind tenon, which is as effective and useful as the dovetail joint, was devised in Japan as a substitute for the dovetail, to be used in places where it is impossible to use the standard dovetail pin.

Sage-kama, **the Wedged Through Half Dovetail Joint** The *sage-kama,* or wedged through half dovetail (Fig. 48), is used when rails must pass through posts. If post and lintel construction is not reinforced and stabilized with bracing, it cannot withstand strong lateral forces, such as earthquakes or the high winds that accompany typhoons. From earliest times, to resist lateral forces rails have been used in Japanese architecture more than the diagonal bracing common to Western architecture.

The rails and tie beams used in Japanese construction also, of course, served the normal functions of horizontal bracing, adding rigidity to the framework and strengthening posts under compression loads. Because these rails are subjected to tension stress, they require joints that not only remain strong under tension but can be made without cutting away so much of the rail that it is unable to withstand stress. The *sage-kama,* either with a through mortise as shown in Figure 48 or blind, as shown overleaf, fills these requirements. In this joint, the half dovetail of the rail in effect hangs on the mortise; and when the wedge is driven in, a very tight joint is made and the rail cannot slip or pull out.

If a rail or beam that passes through a post does not work efficiently along its full

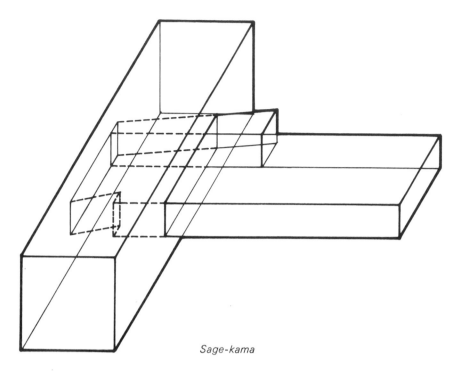

Sage-kama

length, it will not be very effective in tying posts together. Hence, it is not enough to consider only the joint used to connect the rail and the post; thought must also be given to the joints used to splice the rails.

Rails used in Japanese construction are generally 1″ × 6″ (about 2.5 cm. by 15.2 cm.) or 2″ × 10″ (about 5 cm. by 25.3 cm.), so even a small amount of cutting to make a connecting joint quickly weakens them. I think ancient carpenters must have realized this and eventually devised the *sage-kama* as the least destructive method of connecting to the posts the rails that are so necessary to stabilize a structure. Also, because of the tight fit resulting from the wedge this joint is much better adapted for tension stress than the simple half dovetail joint. Although a very complicated joint was devised for connecting rails joining a post from four directions, its strength and usefulness are very doubtful. Perhaps it is better to consider that joint as a technical curiosity. It may well be that a simple through tenon reinforced with nails, for example, is more effective than the *sage-kama*, although this joint would still be quite useful in light construction like cabinets, or even for stretchers for chair or table legs.

Ari-otoshi, **the Housed Dovetail Joint** The dovetail joint gets its name in English because its tenon is thought to resemble the fanlike shape of the tail of a dove, while it gets its Japanese name, literally, "ant joint," because its tenon is thought to resemble the pinched body of an ant. But its construction and uses and the problems of using it are almost the same, East or West. Because the end of the pin, as the dovetail tenon is called, is much wider than the base, a dovetail joint obviously cannot be put together in the same way as a straight mortise and tenon. Because the pin must be dropped into the socket, as the dovetail mortise is known, the socket must always be open on one

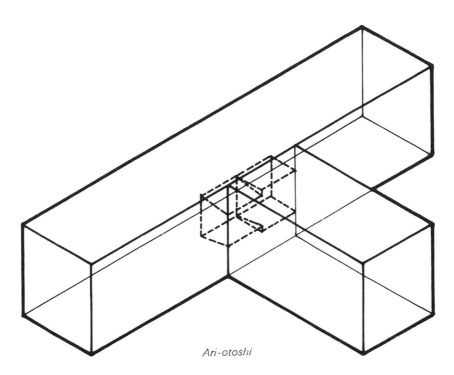

Ari-otoshi

side. But that requirement would seem to make it impossible to use the dovetail for a blind T-shaped connection.

The wedged blind tenon, *jigoku-kusabi*, was devised as one method of overcoming the apparent impossibility of using a dovetail for a blind T-shaped joint. However, there are times when a good carpenter will want to use a dovetail for a T connection but will not want to use the *jigoku-kusabi* because the wedges that split the tenon not only spread the tenon to fit the dovetail socket but also weaken the tenon. Undoubtedly the *ari-otoshi*, or housed dovetail joint, shown above and in Figure 49, was devised as a solution to that problem. In this joint the pin is only about half the width of the tenoned member, while the socket, cut in two steps, is twice the width of the pin. Half the socket is cut as a standard square-sided mortise large enough to accept the widest part of the pin; the other half is cut as a standard dovetail socket. When the joint is put together, the pin is inserted first into the square-sided mortise and from there into the standard dovetail socket.

The joints classed as *ari-otoshi* can be used for connecting joists, girders, and similar members to posts; however, since the flared end of the pin alone must resist all tension stress and the narrow base of the pin, which must resist all shearing stress, can be very weak depending on the direction in which it is cut relative to the grain, it is unreasonable to expect these joints to stand up under very heavy loads. Although these joints can be quite reliable in cabinets or other furniture, in building construction they are really suitable only for temporary framing.

When the pin of a dovetail connecting joint is relatively large, it falls into the general group of joints called simply *ari-kake*, or dovetail joint. Although quite different from one another, the three joints shown in Figures 50–52 are all called *ari-kake*. Dove-

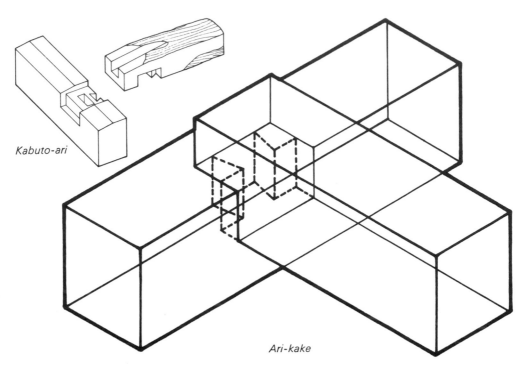

Kabuto-ari

Ari-kake

tail splicing joints all fall into the general class called *ari-tsugi*. Among the *ari-kake*, the blind dovetail shown above and in Figure 52 is perhaps one of the strongest, although if cut with the grain as in the photo, bending or compression force applied to the projecting top of the pin is apt to shear the base of the socket. Among the variations of the *ari-kake* is the *kabuto-ari*, the mortised housed dovetail shown above, which is used on top of a post, with both post and beam mortised to accept a third member.

These joints, particularly the *ari-tsugi*, should be used only where they will not be subjected to a great deal of stress. With small projects, however, dovetailing is very useful for joints where two or three members must be connected in a cross, T, or L shape. We are all familiar with the compound dovetail joint at the corners of drawers, but other variations are equally useful for dividers, framing small cabinet doors, furniture framing, and so forth.

Ōire, the Beveled Shoulder Mortise and Tenon The *ōire*, or beveled shoulder mortise and tenon, shown in Figure 53, is commonly used to connect beams or girders to posts, since the loads they must carry would be too heavy for the tenon to bear alone. The notch in the mortised member supports part of the load borne by the tenoned member, making this joint substantially stronger than a plain square-shouldered through mortise and tenon. The beveled shoulder mortise and tenon can be made either with a stub tenon as shown in Figure 53 or with a through tenon, which may be a bit more common in Western construction.

The main structural posts in Japanese construction are solid from groundsill to pole plate, whether the structure is one, two, or even three stories high. Whether beams join such a post from two directions or four, one must be careful to avoid weakening

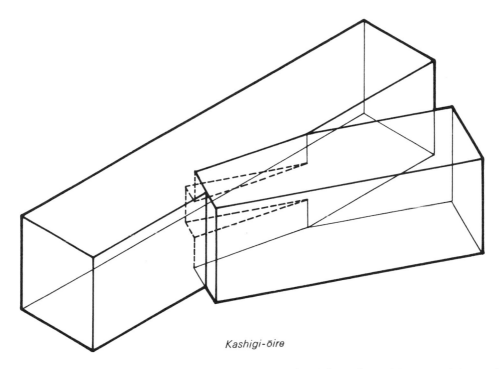

Kashigi-ōire

the post; but when beams are let in at the same level from four sides, special care is required. Four mortises quickly reduce a solid 15 cm. square post (roughly 6″ × 6″) to a far less reliable group of four 5 cm. square posts (about 2″ × 2″), resembling the multiple tenons of the *jūji-mechigai-tsugi* (Fig. 30). Apart from the problem of weakening a post, the carpenter must take into consideration just how the structures of such joints will fit together physically. When letting in four beams, careless carpenters have been dismayed to find that tenons that are too long or notches and beveled shoulders that are not modified to accommodate adjoining members make it impossible to fit the joints together properly. The master carpenter displays his skill in the cutting and finishing of these joints, putting them together like a gigantic version of a Chinese puzzle.

Being an angled joint, the *kashigi-ōire*, or notched mortise and tenon (shown above and in Figure 54), can easily be used for diagonal bracing, although for such use the notch should be cut at an acute angle to keep the brace from slipping out under stress. The whole, barked logs often used for beams in traditional Japanese construction are often very eccentrically curved. When such eccentric beams join posts at a sharp angle, it is almost impossible to use the *ōire*, and the *kashigi-ōire* is especially useful for connecting this type of beam to a post. It is equally useful for connecting true horizontal members to these great, curved beams. Because of the way the tenon and notch are cut for the *kashigi-ōire* the bearing area of the joint is not only increased but strengthened and a large mortise, which would weaken the post, is not required.

Both the *ōire* and the *kashigi-ōire* are usually reinforced with metal, with anchor straps or bolts generally used to reinforce the *kashigi-ōire*. Sometimes a bolt through the tenon of the *ōire* is sufficient; but often, where two *ōire* join a post from opposite sides, horizontal straps are used to tie the tenoned members to each other and to the

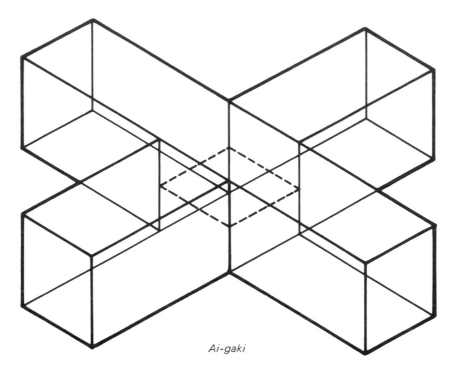

Ai-gaki

post. Where four beams join a post, as frequently happens in floor framing, whether they are let in all on one level or on two levels, special care must also be given to reinforcing the post, even if just by banding. If the post is not properly reinforced, it can give way under stress, and careful reinforcement of the joints will have been wasted effort.

***Ai-gaki,* the Cross Lap Joint**　When it is necessary to have a flush joint where two members cross each other, a mortise must be cut in each member, halving the members. Although such joints are beautiful, as can be seen in the photograph of the *ai-gaki*, or cross lap joint (Fig. 55), and in the isometric projection above, structurally they are quite weak, since it is necessary to cut away half a beam to make them. In addition, because so much of a beam must be cut away, these joints are far more vulnerable to severe weakening and damage because of seasoning checks and splits. The *watari-ago*, a cogged lap joint, shown at right and in Figure 56, is a variation of the cross lap joint that overcomes some of the shortcomings of the *ai-gaki*, although it does not make a flush joint.

In building construction, lap or half lap joints are commonly used to let diagonal braces into studs. It is difficult to make these oblique joints accurate, however, so they tend to be even weaker than a right angle cross lap joint. In general, the joints that fail during an earthquake are the half lap joints, and oblique lap joints fail more often than any other type. Lap joints are also used at corners in groundsill construction and at corners of wall and pole plates in Japanese-style hipped-and-gabled roof construction, where it is necessary to have flat, square joints to support the ends of the hip rafters.

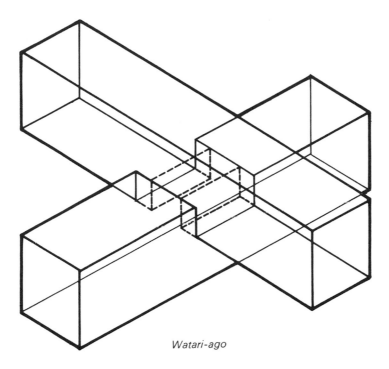

Watari-ago

Lap joints, which are called halving joints by Western cabinetmakers, are both useful and reliable when employed in work involving small stock, such as picture frames, furniture framing, and cabinets. Their numerous variants are the most commonly used joints in cabinetmaking because they are easily made and, with small stock, relatively strong.

In major construction, lap joints are used not only at corners but also where joists or other cross members join or cross girders or other beams. Sometimes it may be necessary to finish these joints flush, in which case a half lap joint must be used; but it is far more desirable that only a very small mortise be cut in a girder or other horizontal bearing beam.

When beams that run both the length and breadth of a structure must cross each other, as often happens in traditional Japanese architecture, the *watari-ago* is generally used. While this cogged lap joint does not produce a completely flush joint, it does offer a considerable advantage over the *ai-gaki*, or cross lap, since the bearing girder or beam is not halved but has only smaller notches or mortises cut into it. This joint is therefore much stronger than the *ai-gaki*, since only one of its members is halved and the member subject to the greater bending or compression force is left largely intact. Because this joint only slightly weakens bearing beams it is frequently used and is often seen in the exposed roof trusses familiar to both Japanese and Western tourists who visit the many old farmhouses and residences now open to the public.

Complex Joints The *hōgyōzukuri-nokigeta-shiguchi* shown overleaf and in Figure 57, is a truly complex joint, which can be used where post, pole plate, and crossbeam meet. I have included it here only as an example of one of the more complicated joints

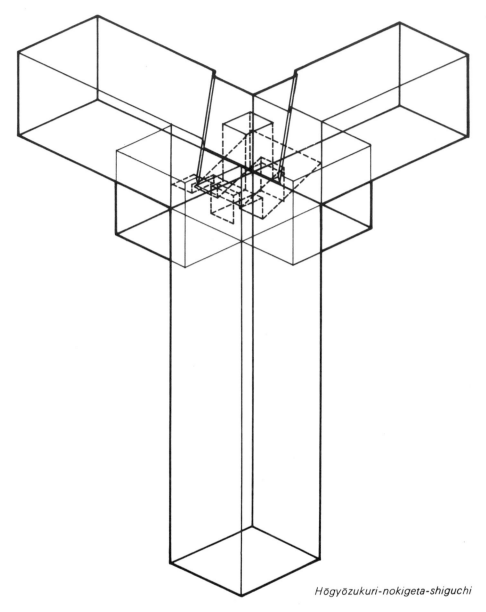

Hōgyōzukuri-nokigeta-shiguchi

used in Japanese carpentry. In terms of design and complexity, it is quite beautiful, but it requires great delicacy and precision in cutting and fitting together. It is, in truth, a delicate joint not at all reliable for major construction, yet one cannot help admiring the beauty of its composition, which is appreciated far more than its reliability. Although I would not recommend this joint for use anywhere by the amateur carpenter—even the master carpenter finds it troublesome—it is an outstanding example of the degree of complexity often achieved in Japanese joinery. This tribute to the ingenuity of Japanese carpenters may even serve as a challenge to some adventurous Western carpenter who appreciates the beauty of joinery as I do.

 The "weathermark" identifies this book as a production of Weatherhill, publishers of fine books on Asia and the Pacific. Supervising editor: Suzanne Trumbull. Book design and typography: Rebecca Davis.